Fantasy Art

by
Mathew Jordan Assemes

About the Artist

I was born in Reading Pennsylvania in 1976 to two extraordinary people, and it's without a doubt that my hope and optimism has stemmed from their determination. I remember many times being left without electricity in the house and doing without the simplest of luxuries, but my Father's spirit and my Mother's strength held my whole world together and had eventually taken an unfortunate family to a place of stability and well-being.

I started drawing at an early age and have always been obsessed with invention and design. My room was perpetually cluttered with paper aircrafts and cardboard castles, and even in the midst of my Mother's cleaning frenzies, I managed to stash away my treasures beneath my bed and in the back of my closet. I believe that both my multi-cultured family and creativity drove an unquenchable thirst for the arts; usually leading me to hunt through my Father's book collection to study the works of Rembrandt and Parrish.

In the year 2000, I began a portrait business. I have sold hundreds of commissioned portraits from that time until now, but my love will and has always been with the world of fantasy and surrealism. I am driven to tell stories in my artwork and to piece together a place of magic. It is an endless pursuit and passion that I can't explain.

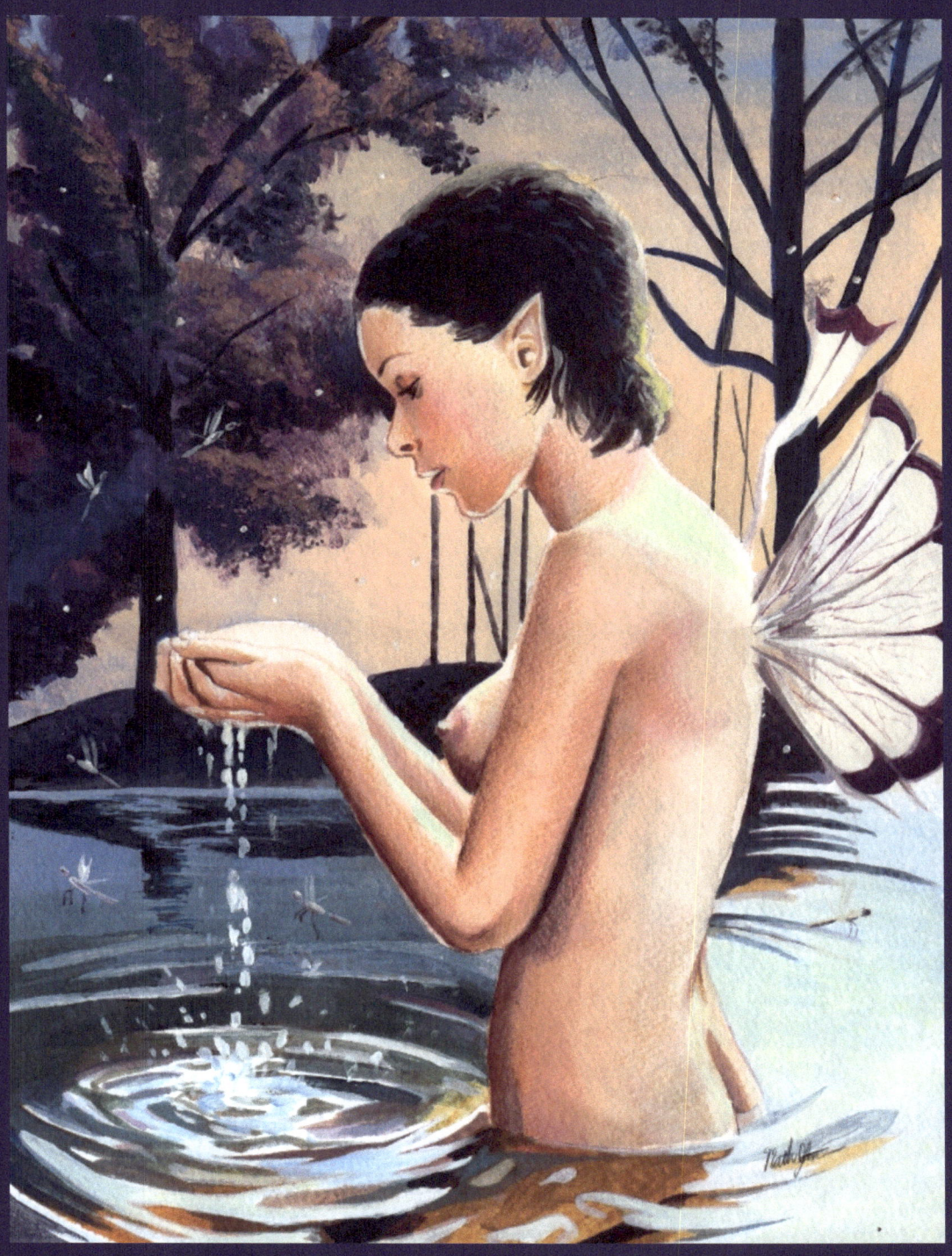

Dragonflies
Watercolor, Colored Pencil and Acrylic

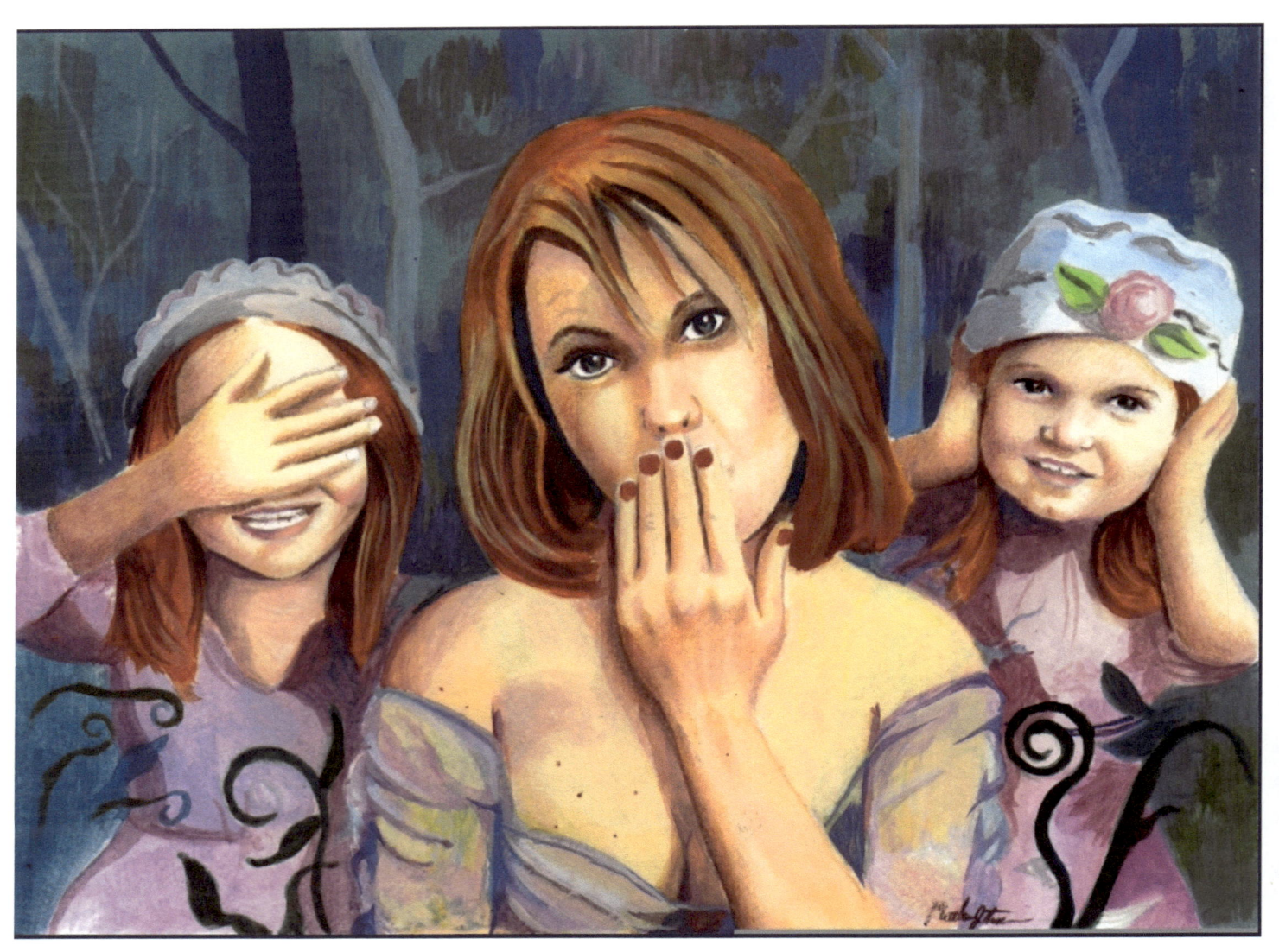

See No Evil, Speak No Evil, Hear No Evil

Watercolor, Acrylic and Colored Pencil

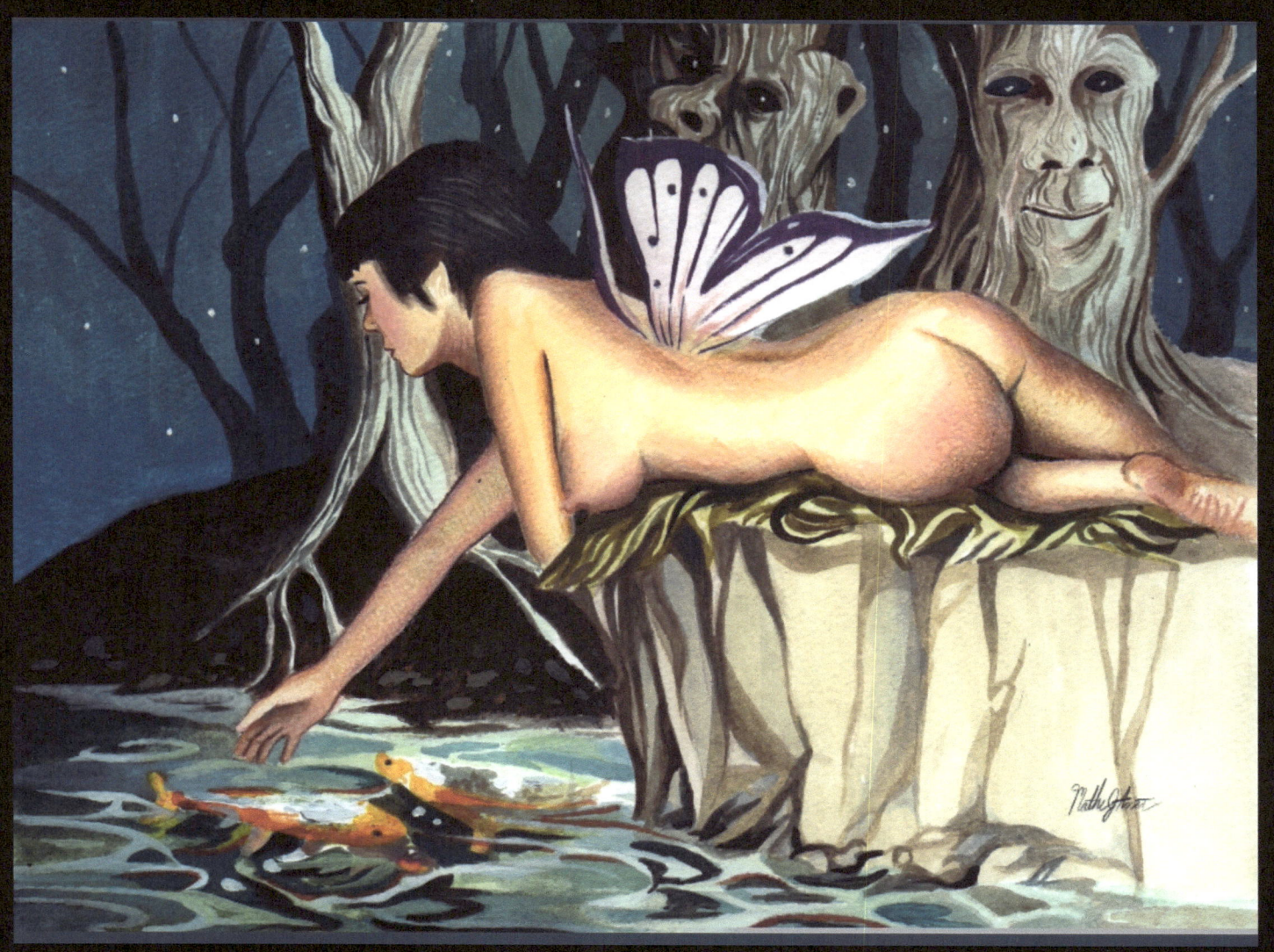

Coy Fish

Watercolor, Colored Pencil and Acrylic

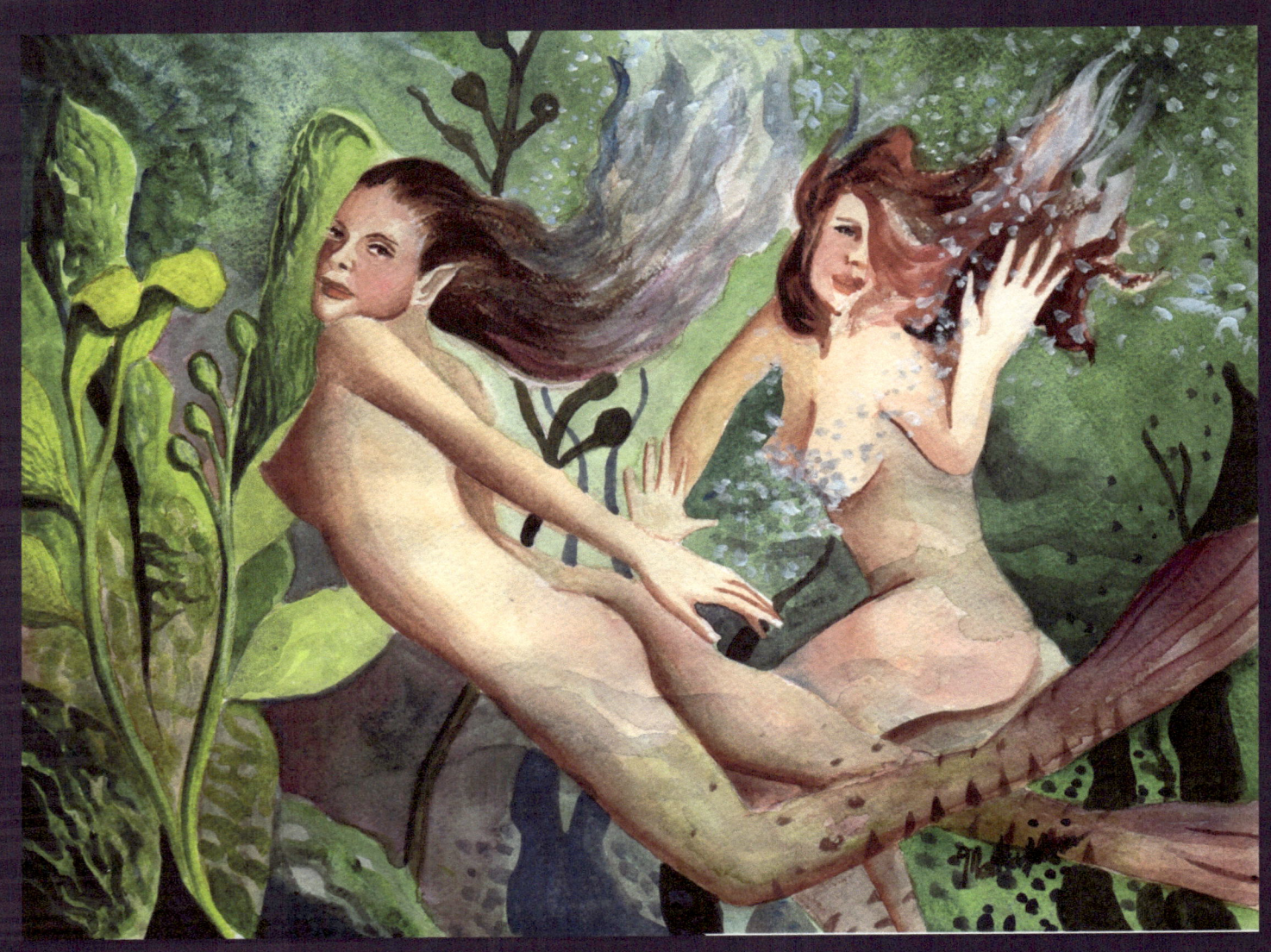

Guaramis

Watercolor, Colored Pencil and Acrylic

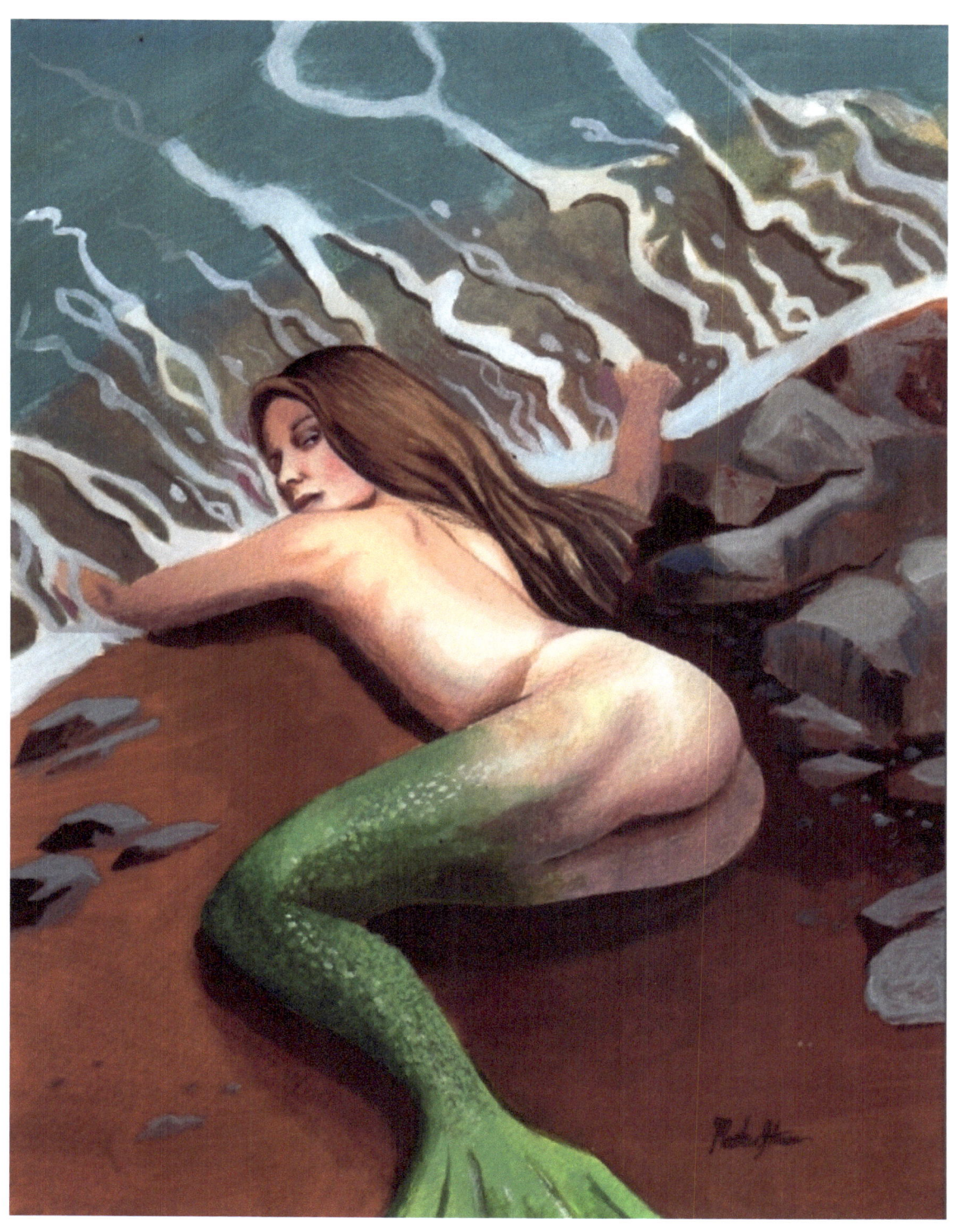

Sun Bathing

Acrylic

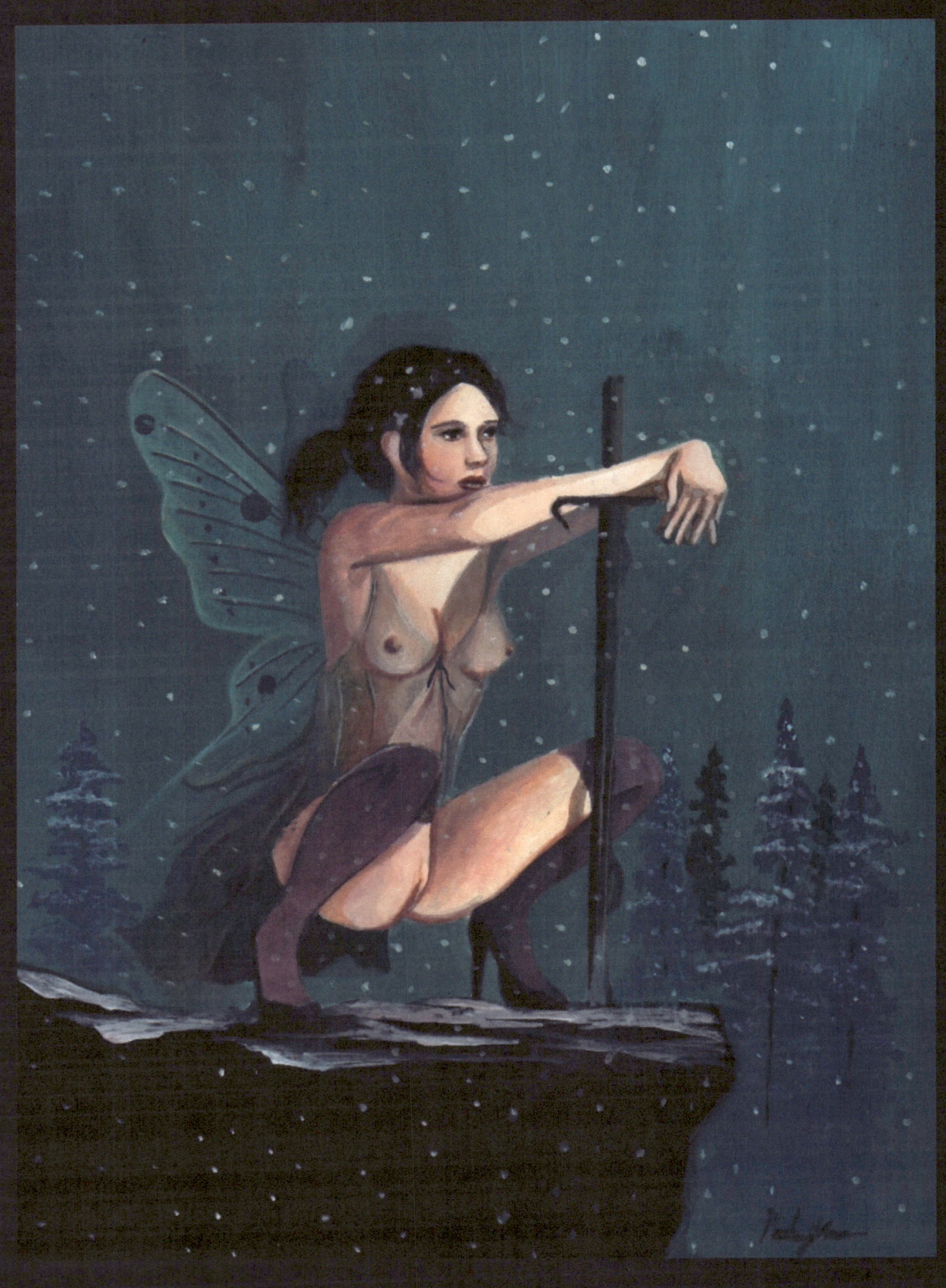

Snow Fairy

Acrylic

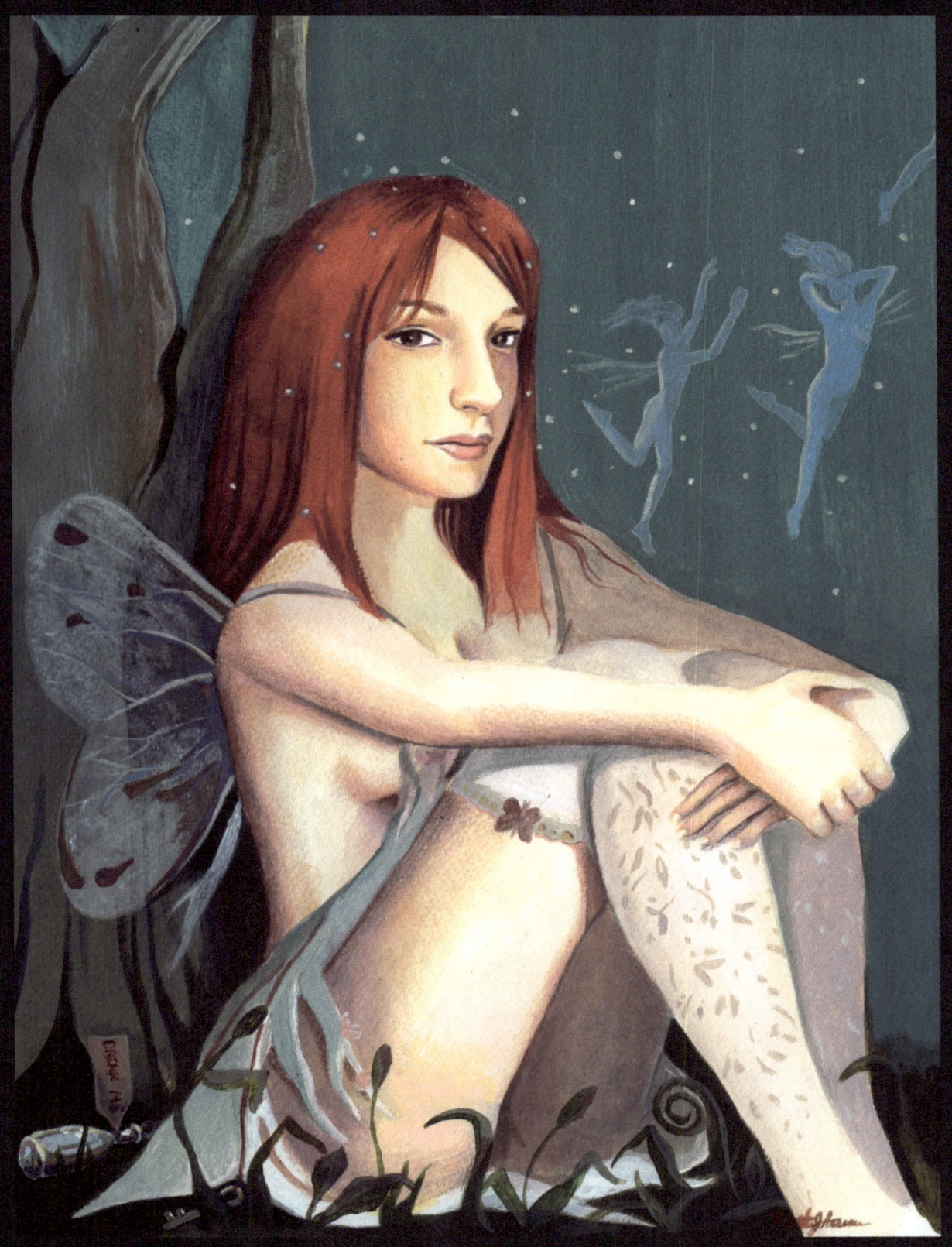

A Fairy Portrait

Watercolor, Acrylic and Colored Pencil

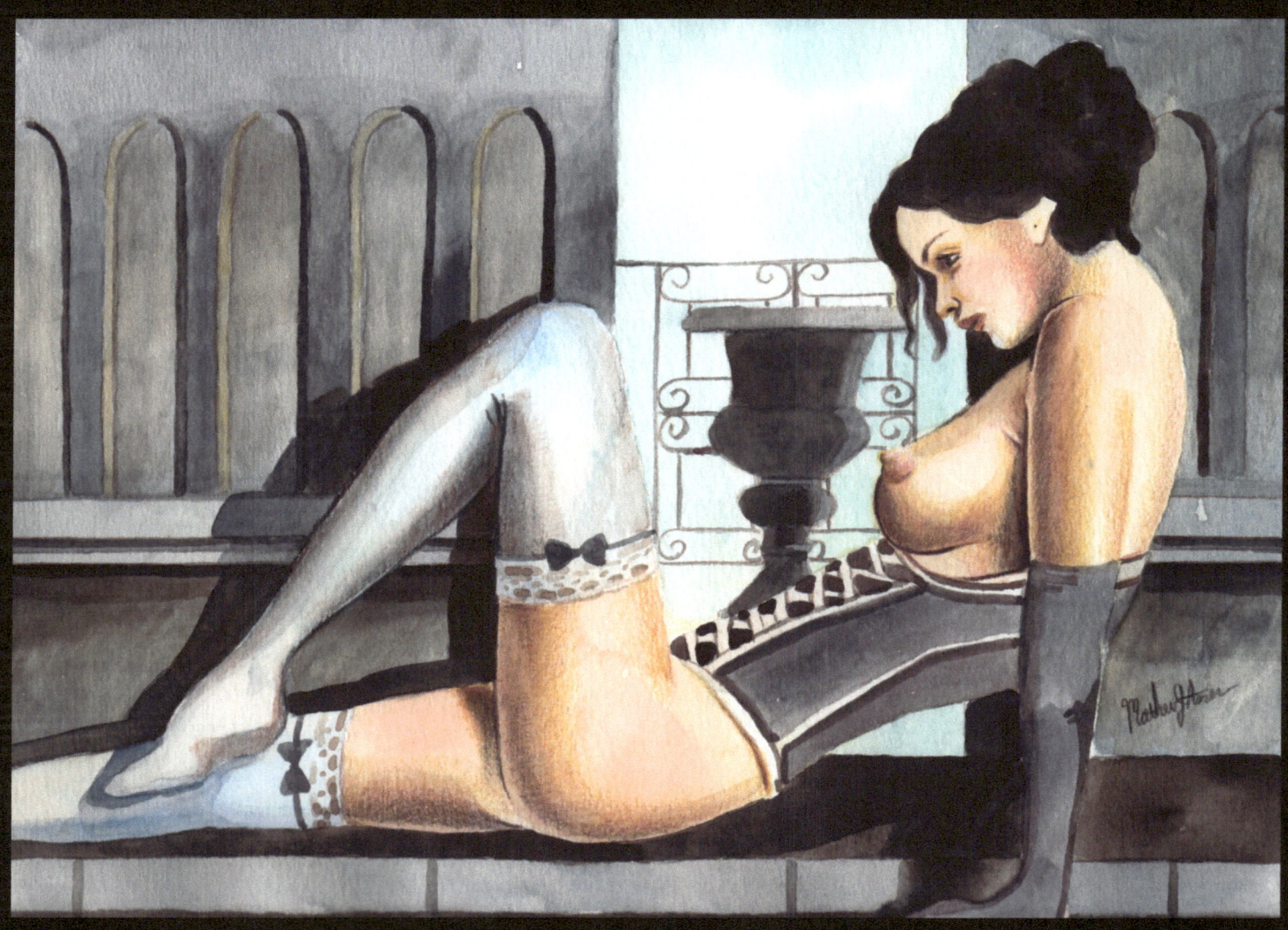

Ornament

Watercolor and Colored Pencil

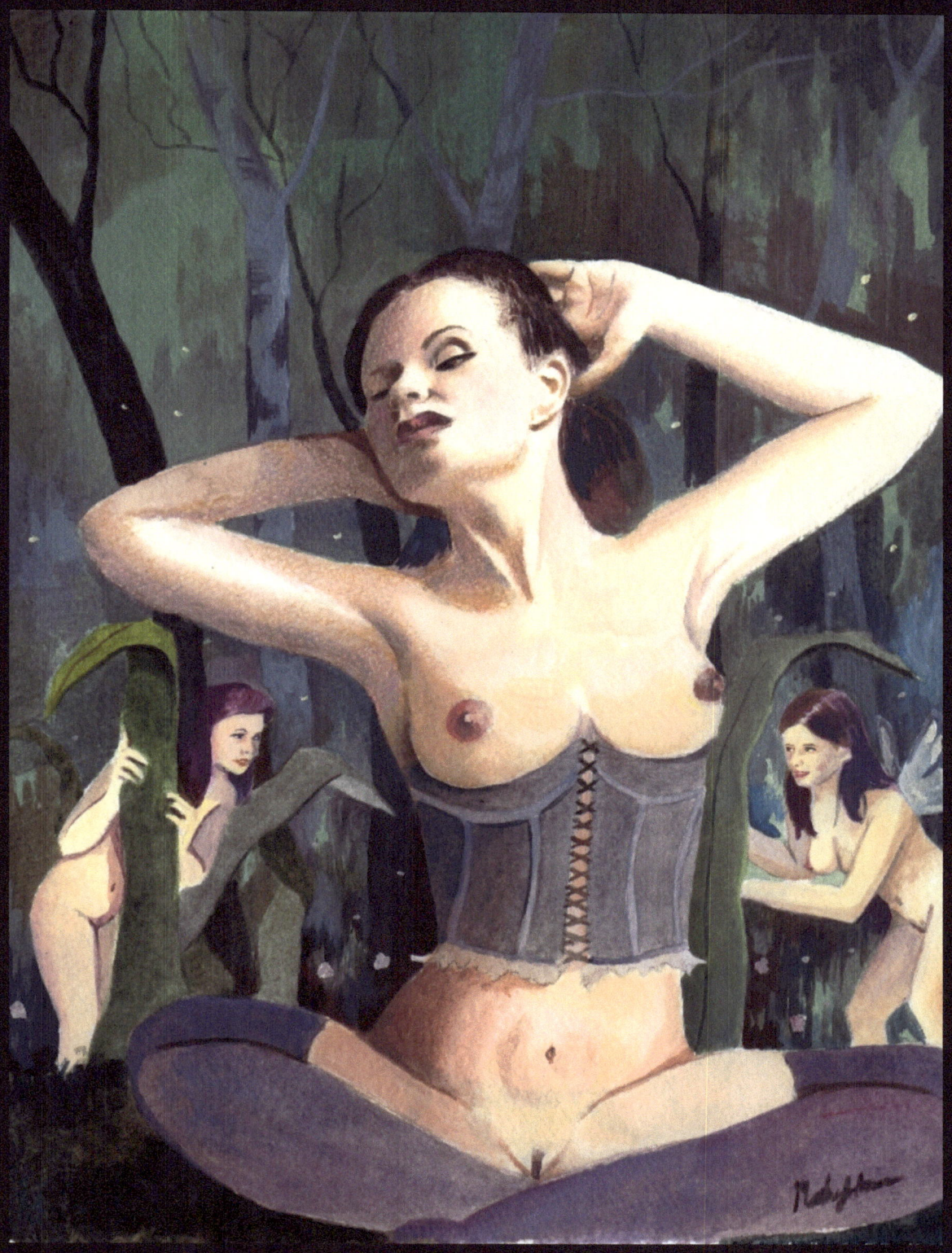

Little Faces
Watercolor, Colored Pencil and Acrylic

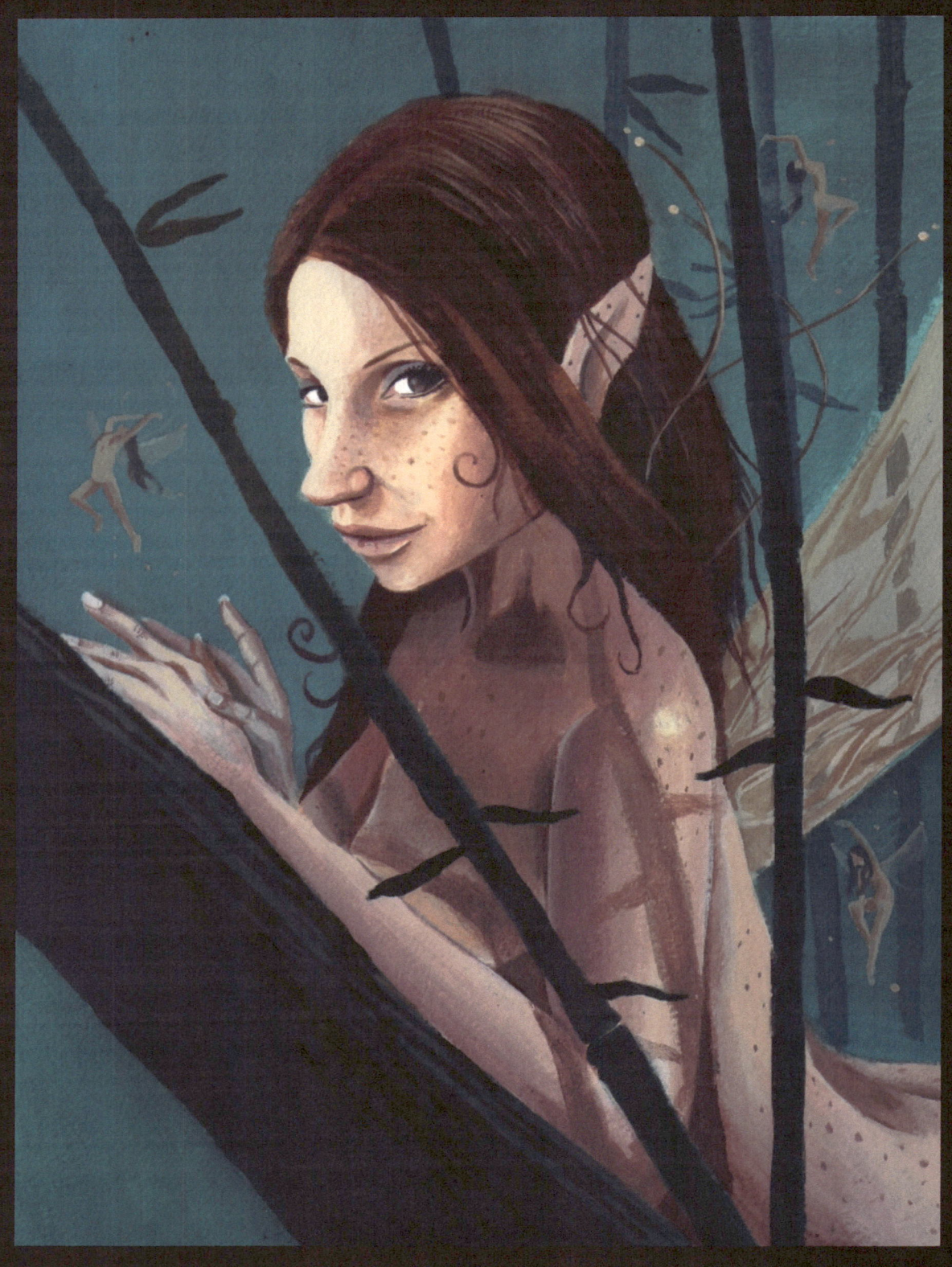

Hidden Secrets

Acrylic

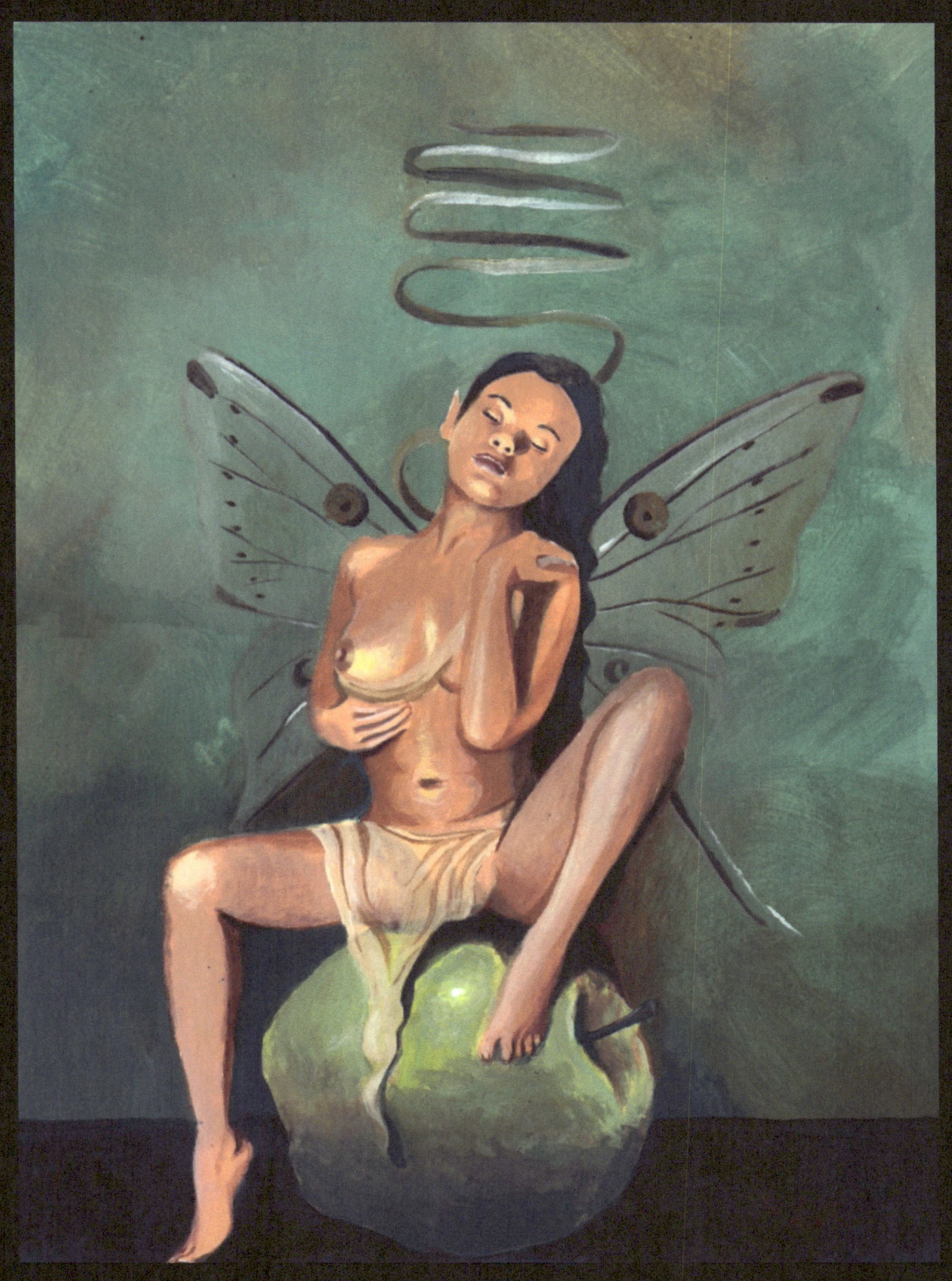

Green Apple

Acrylic

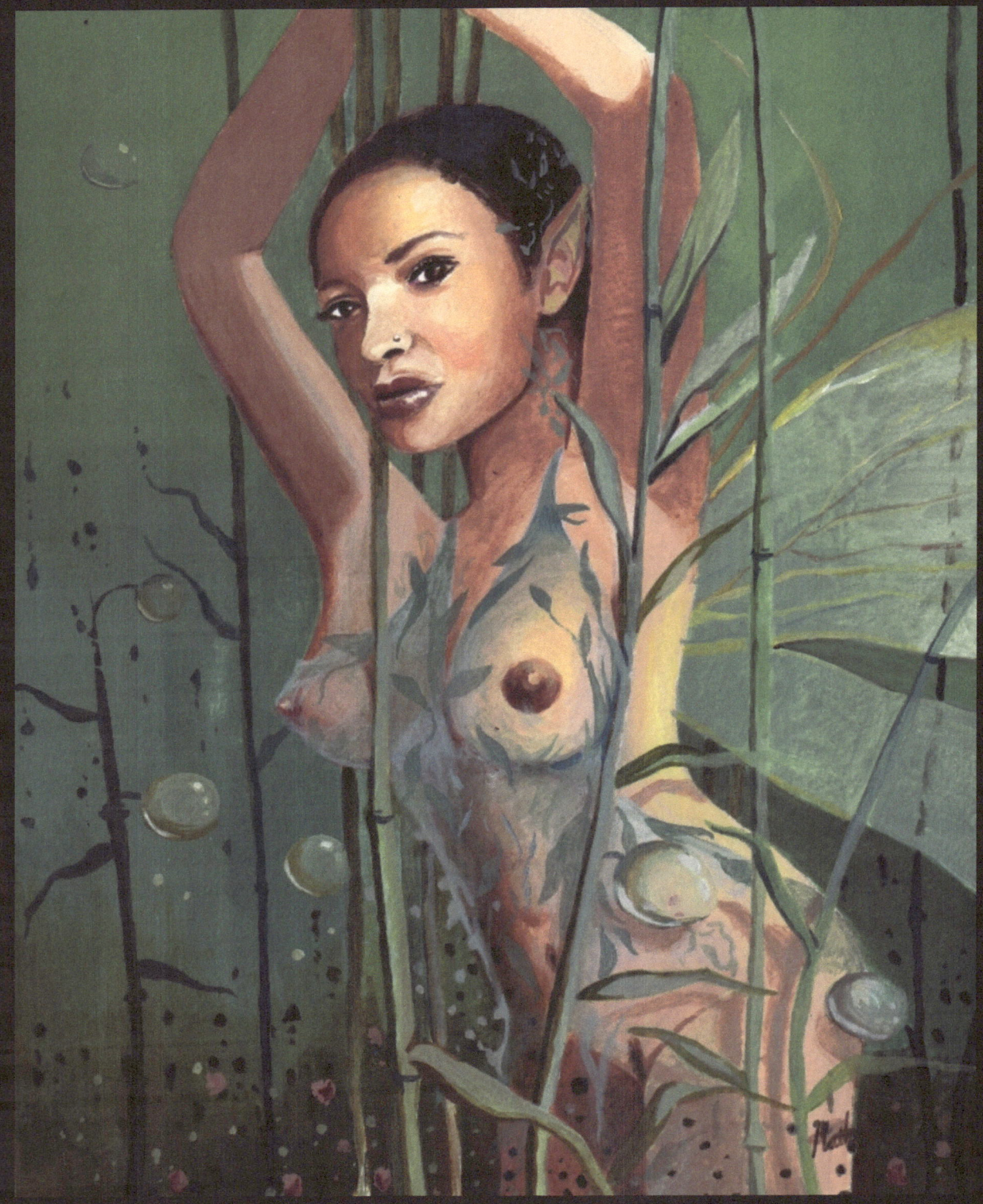

Entwined

Acrylic

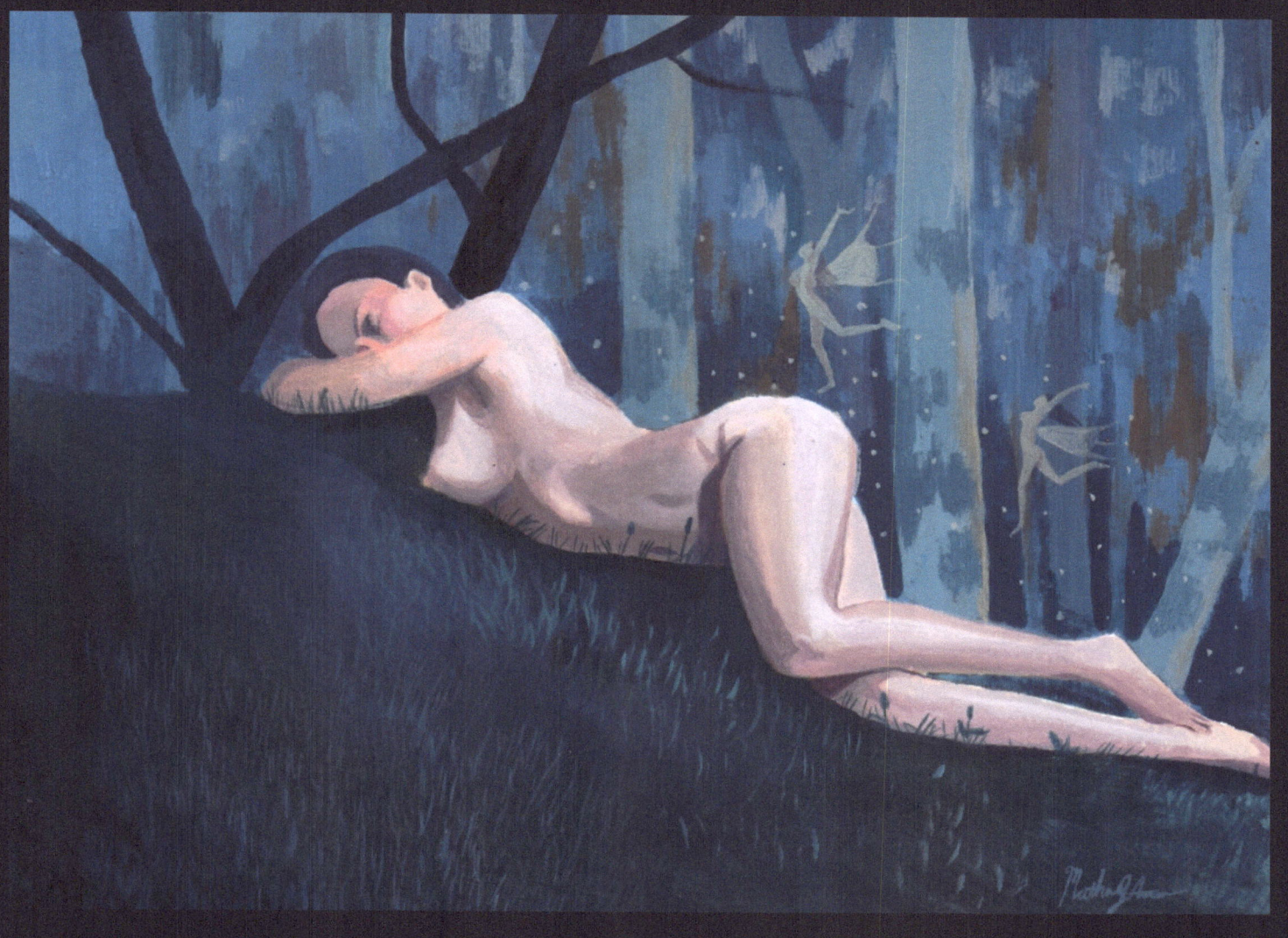

Wishing Part I

Acrylic

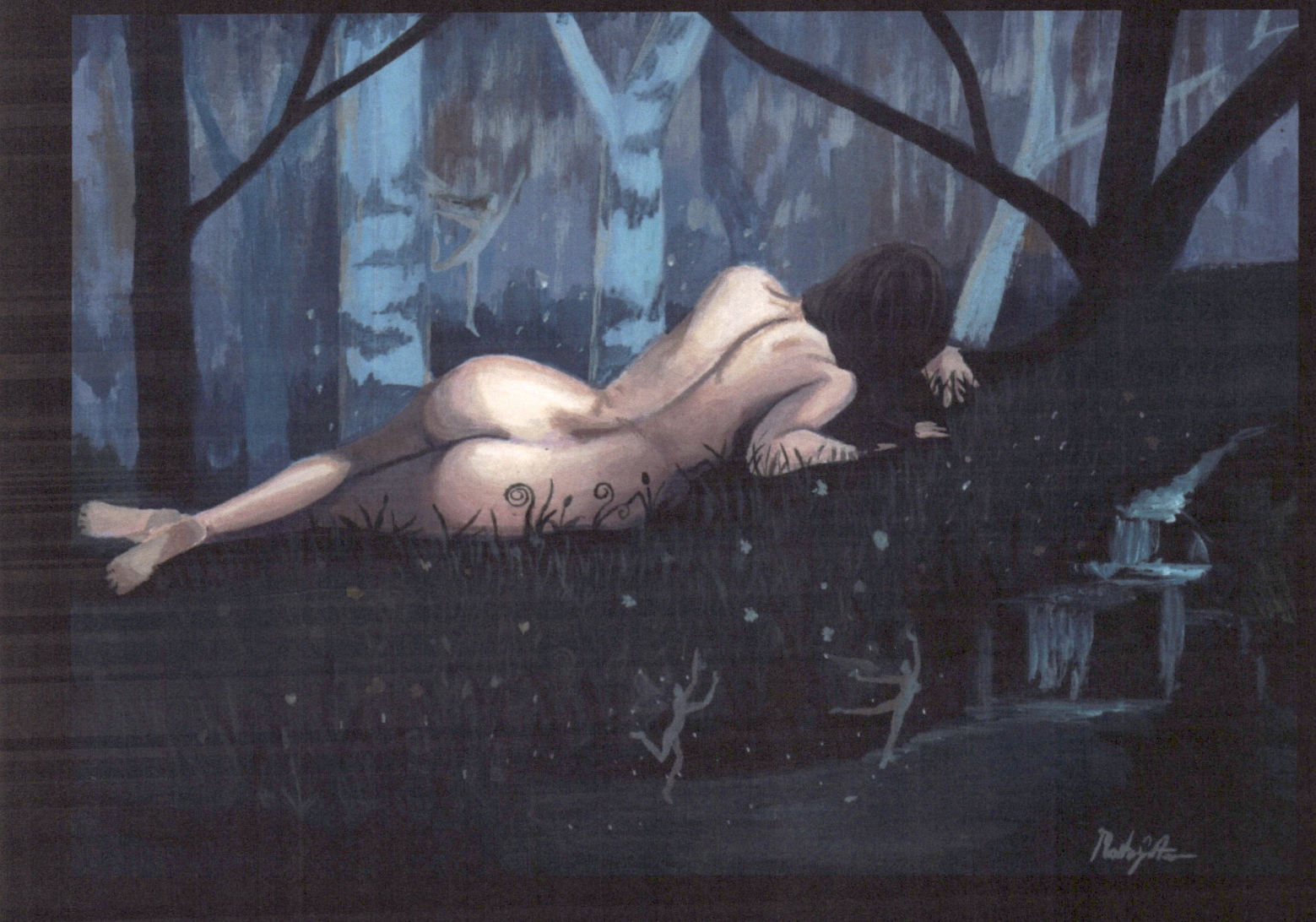

Wishing Part II

Acrylic

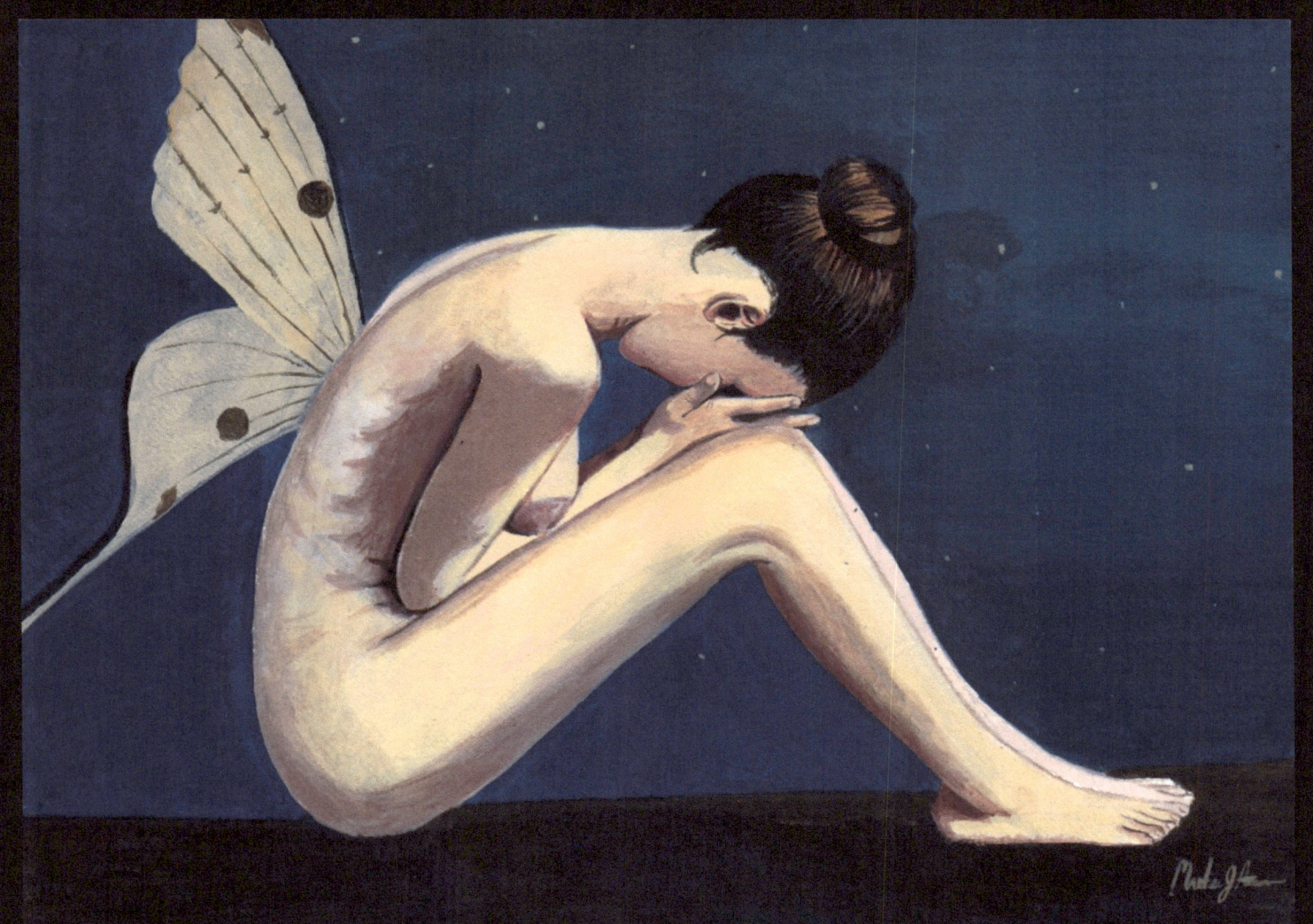

Sorrow

Acrylic

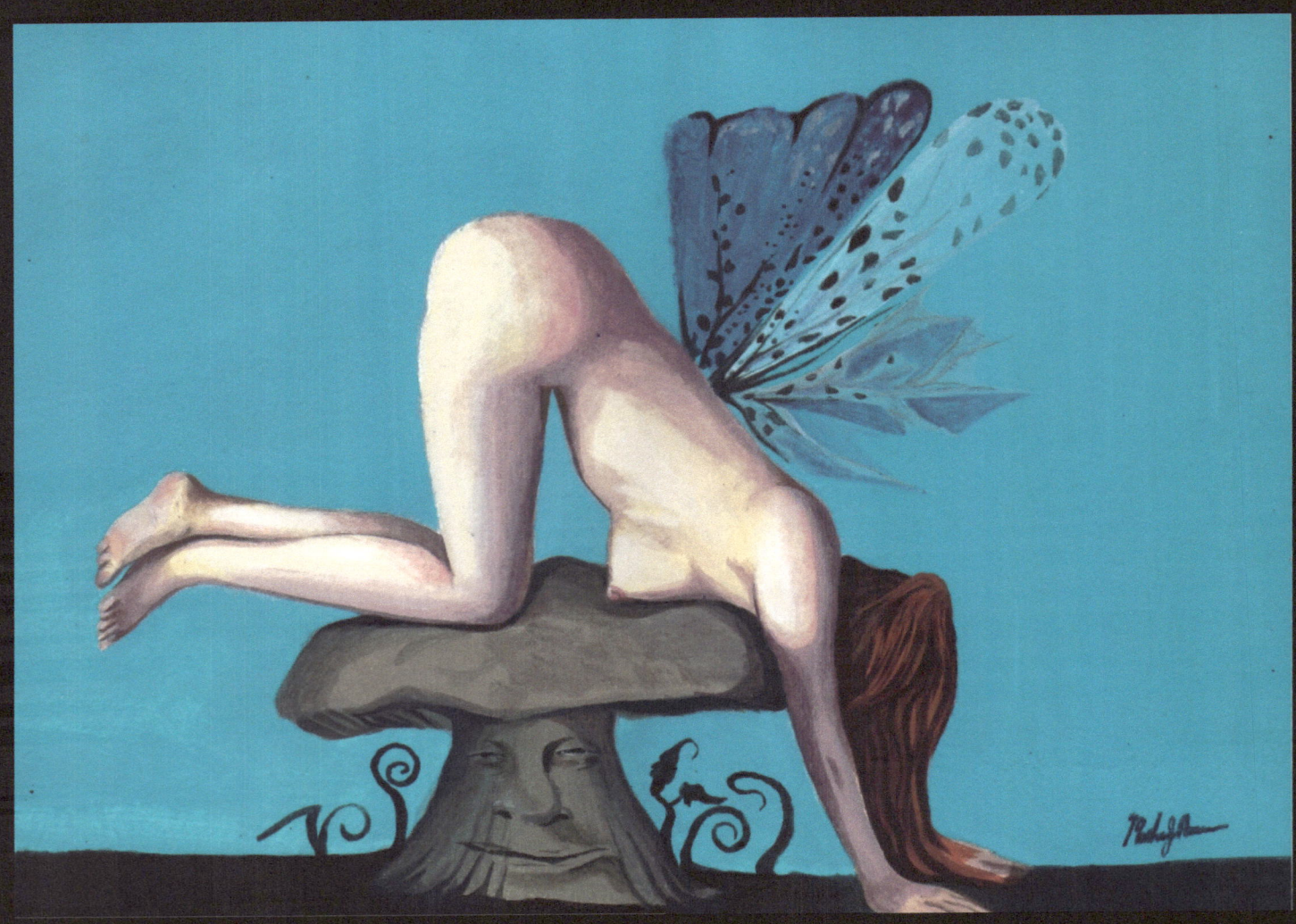

Playful

Acrylic

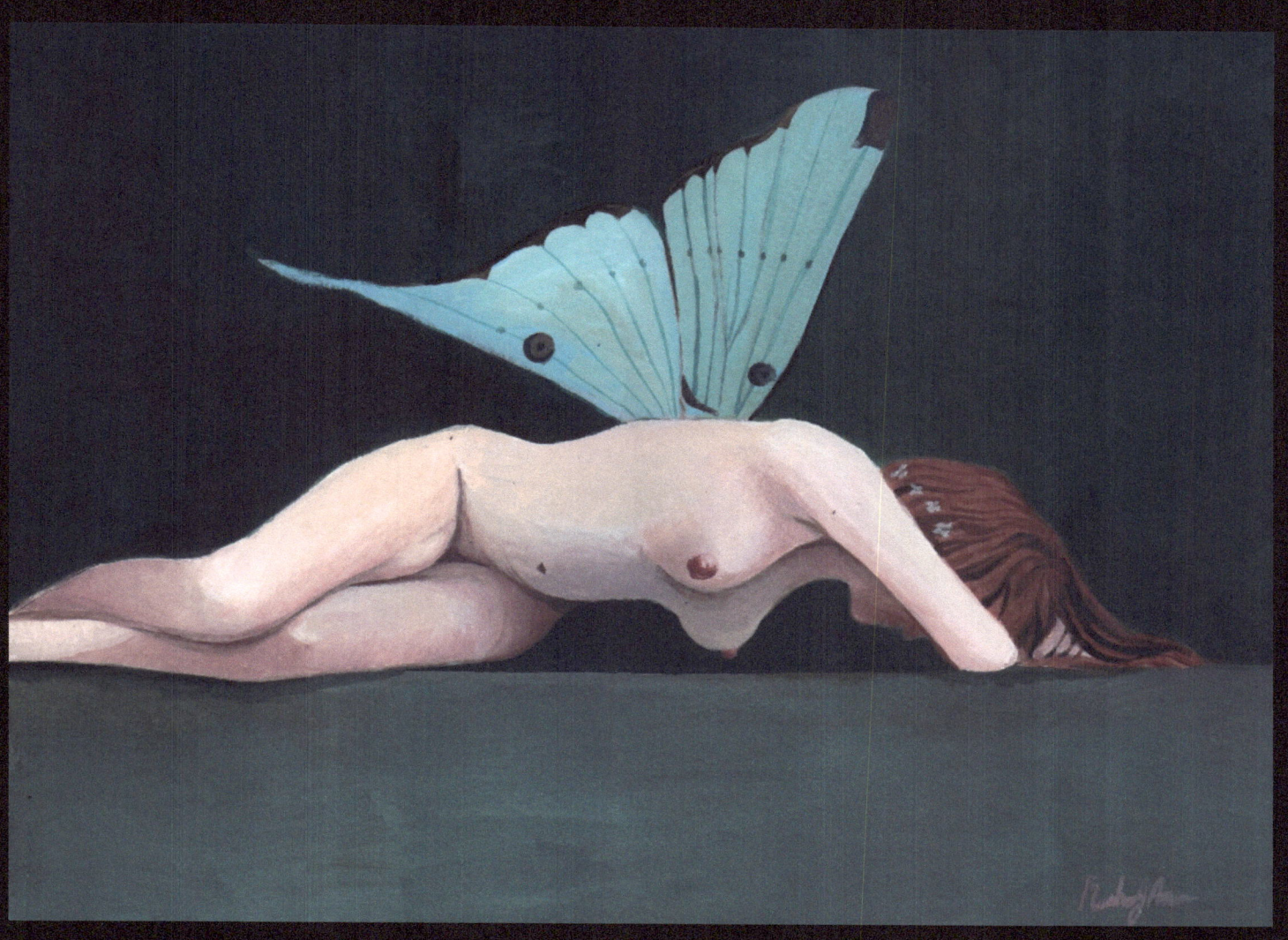

Moods

Acrylic

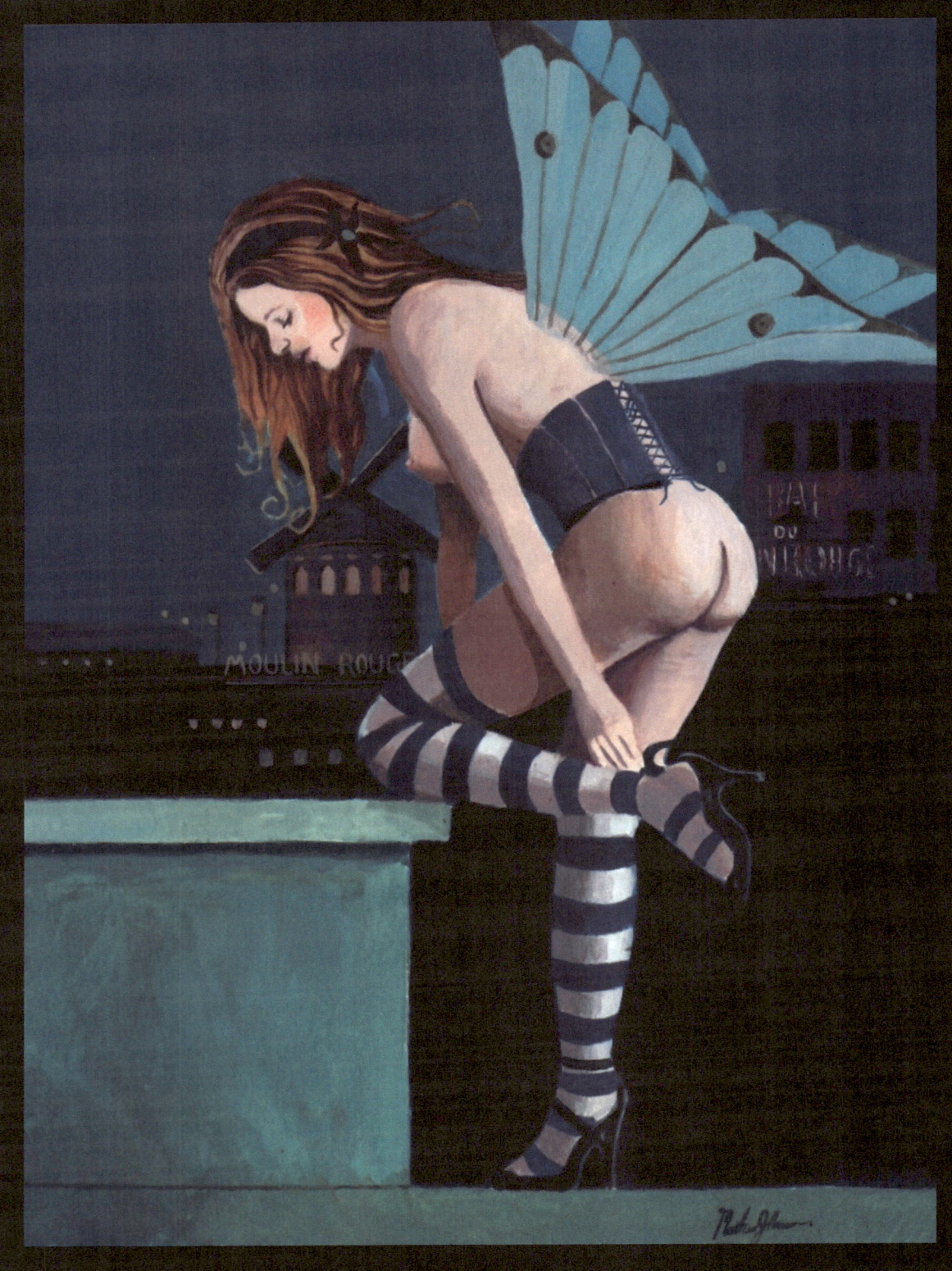

At the Mulin Rouge

Acrylic

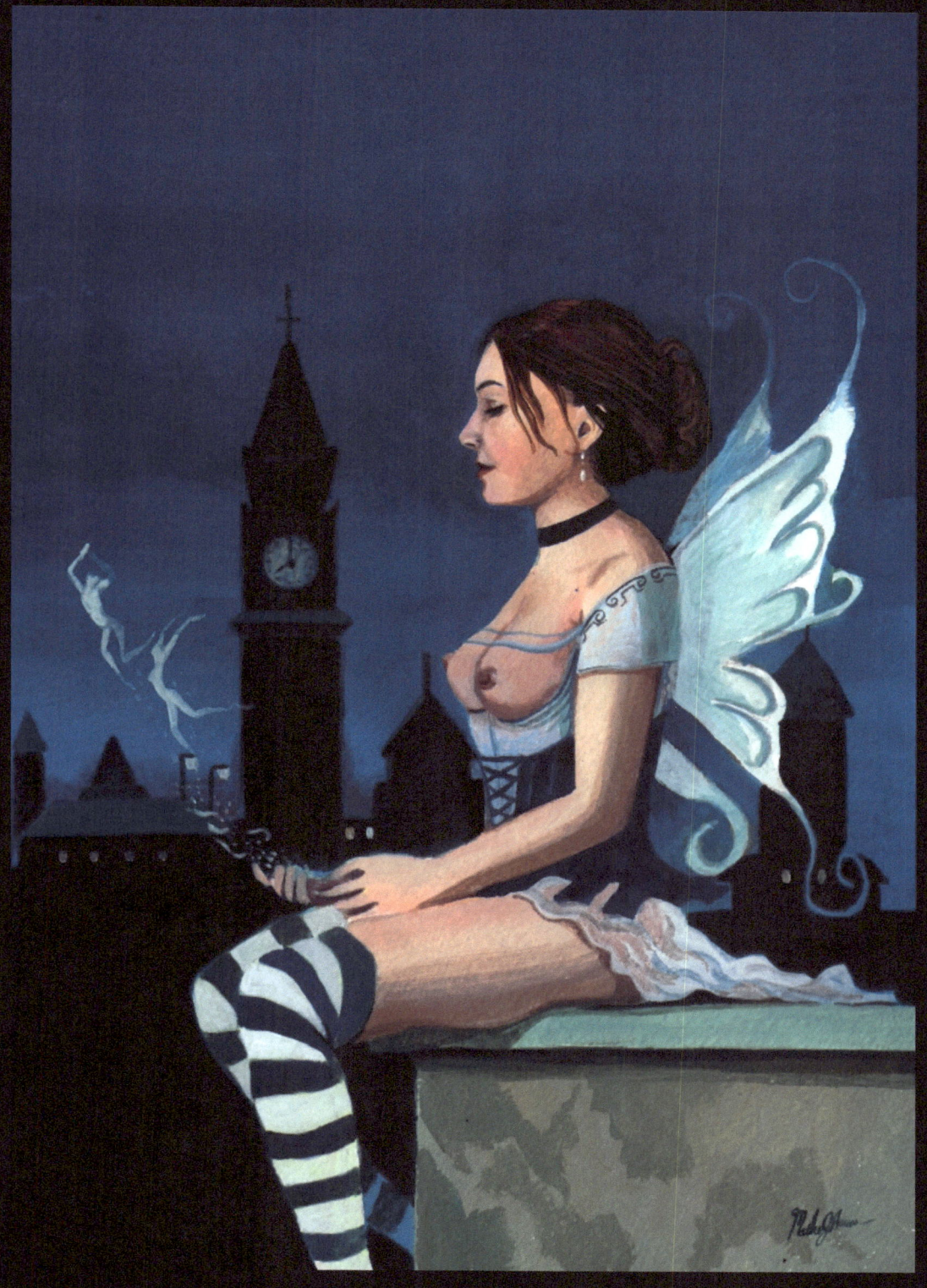

The Clocktower

Acrylic

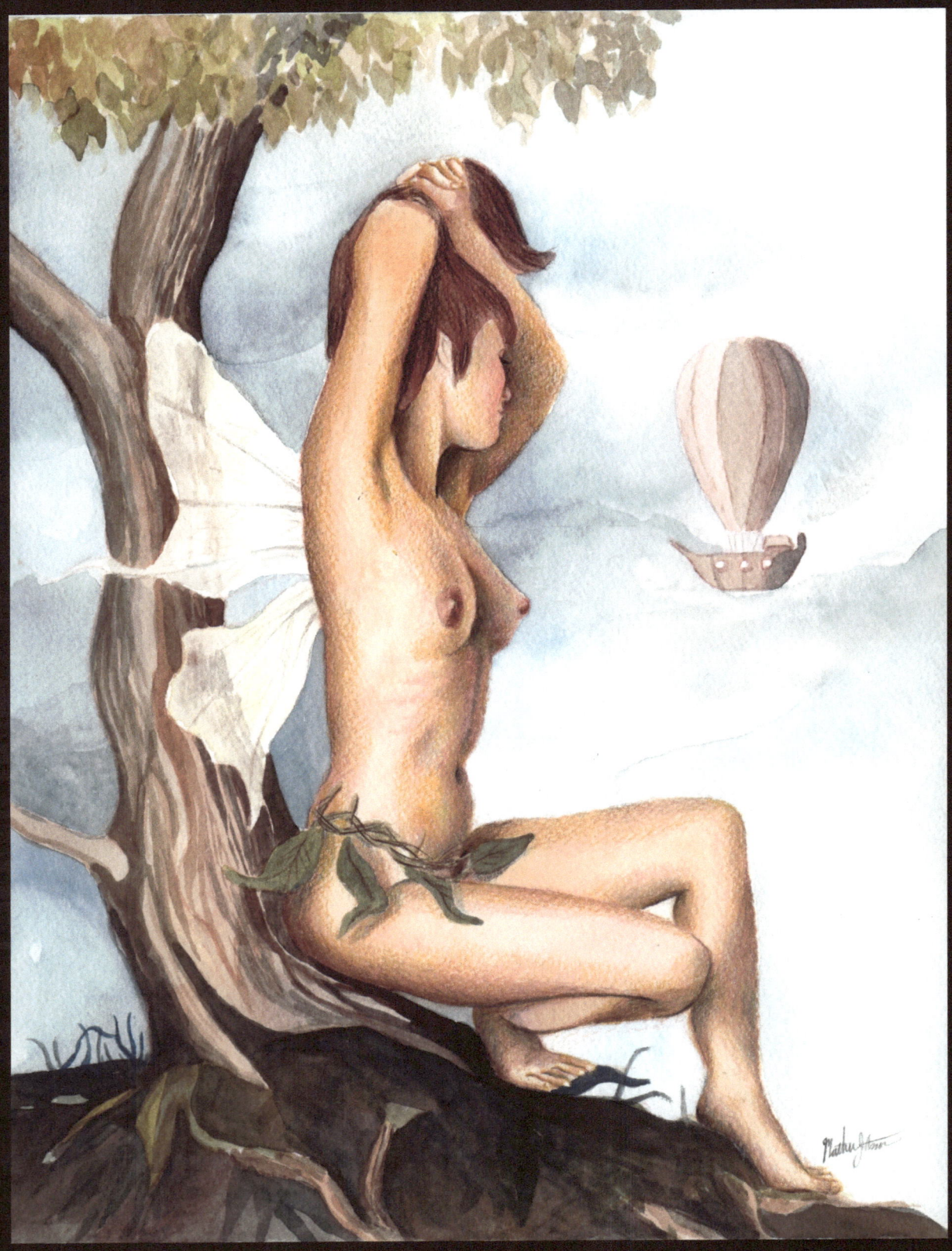

The Air Ship
Watercolor and Colored Pencil

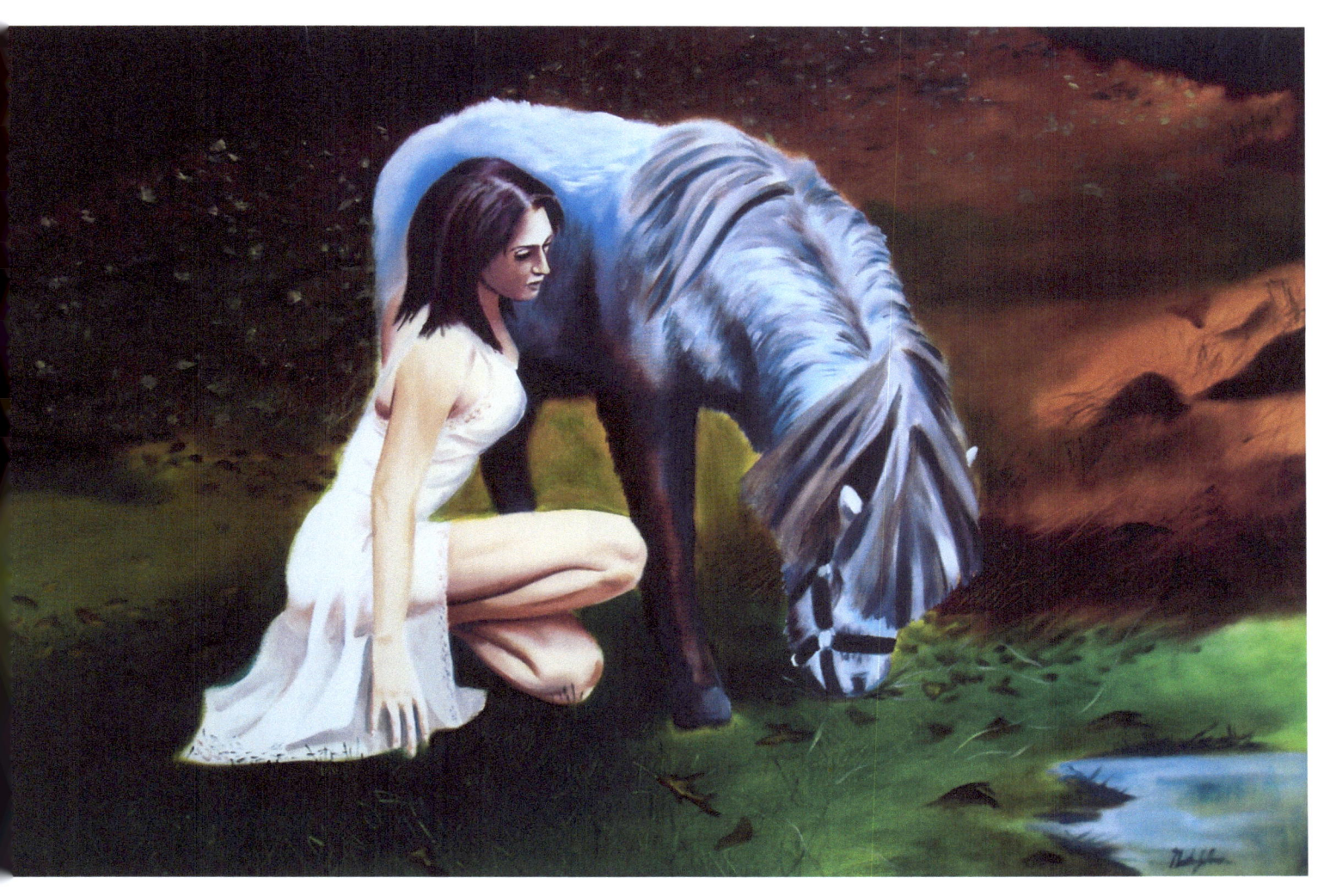

Morning Light

Oil on Canvas

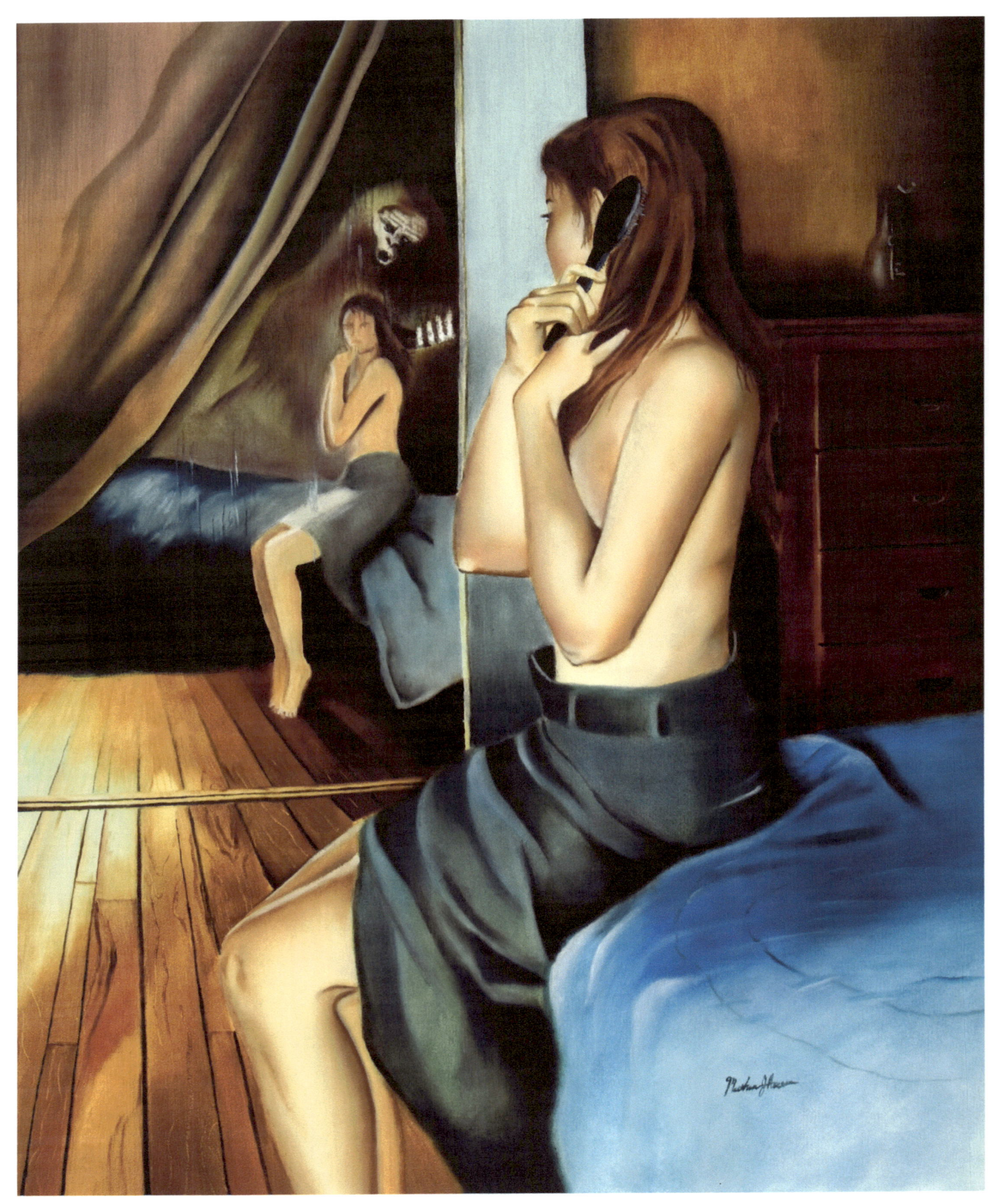

The Phantom
The Mask Collection
Oil on Canvas

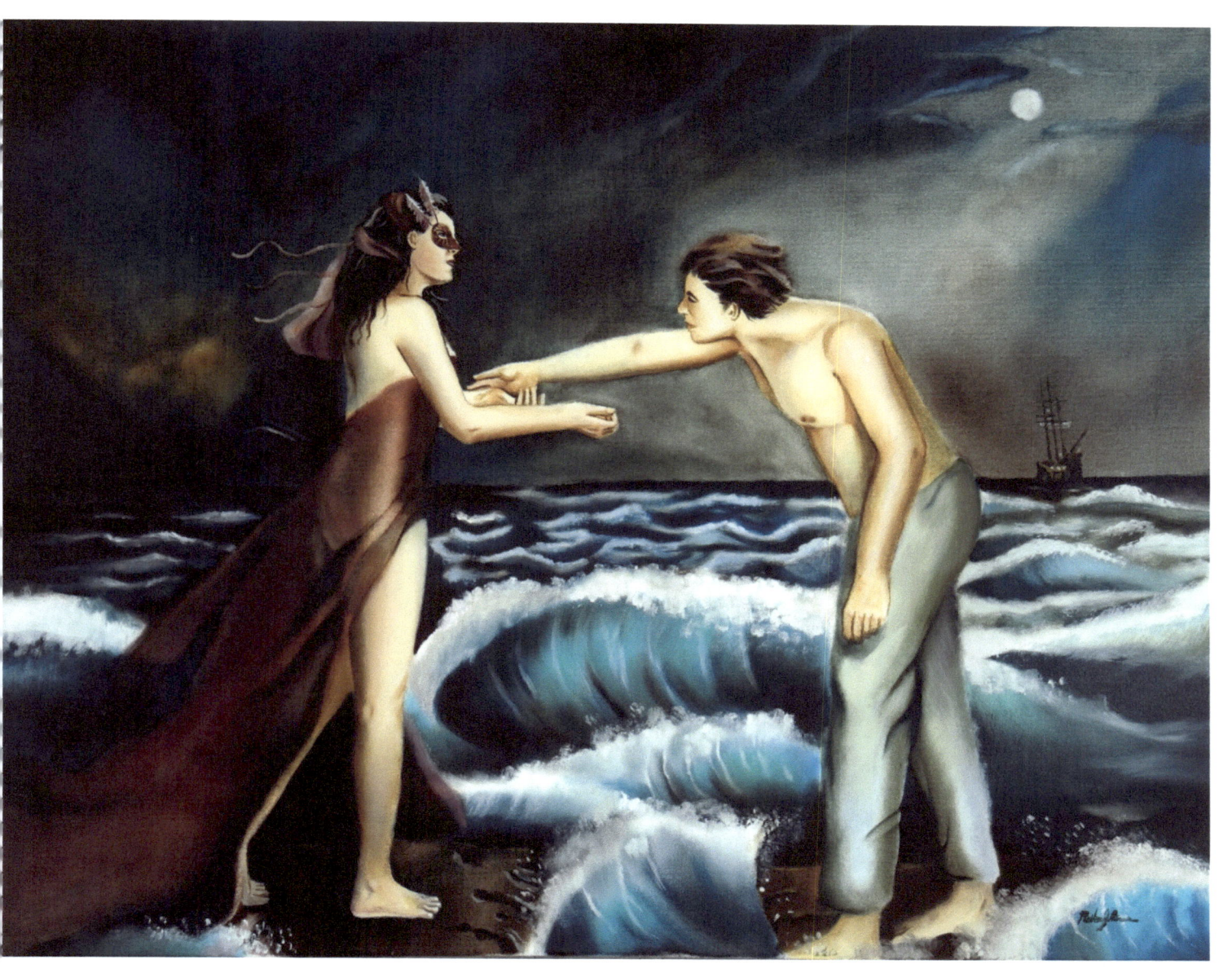

The Storm
The Mask Collection
Oil on Canvas

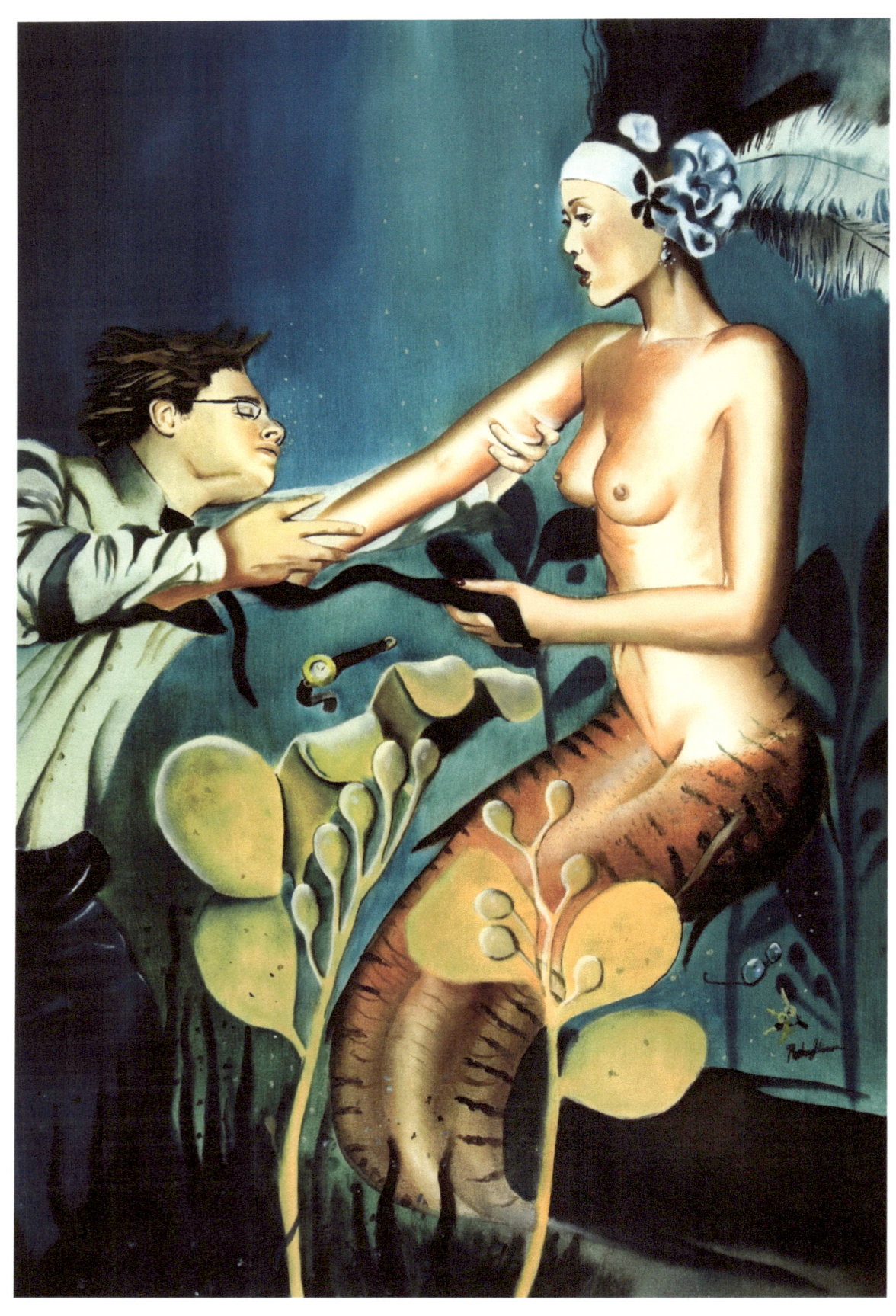

Guarami
The Mask Collection
Oil on Canvas

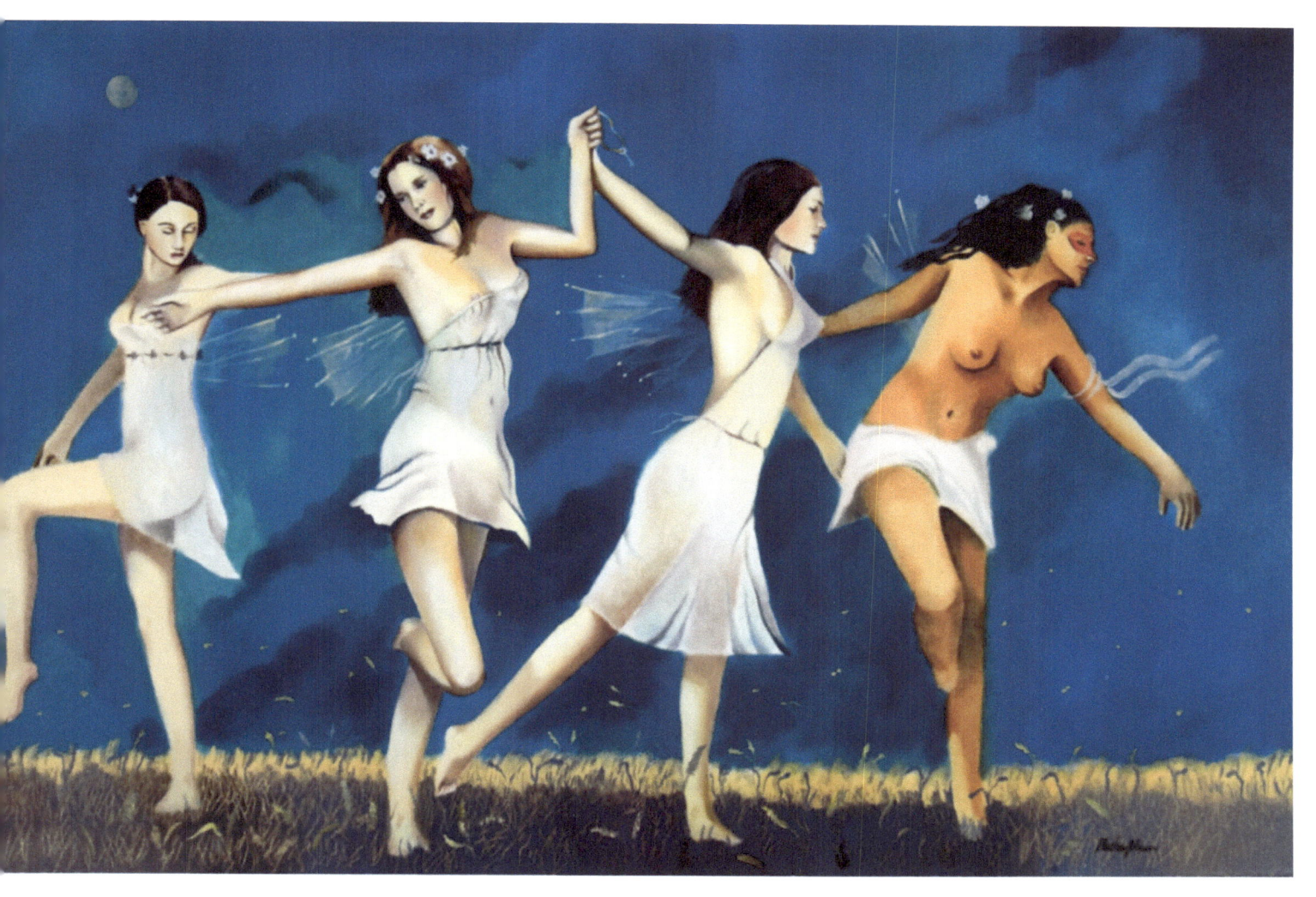

The Dance
The Mask Collection
Oil on Canvas

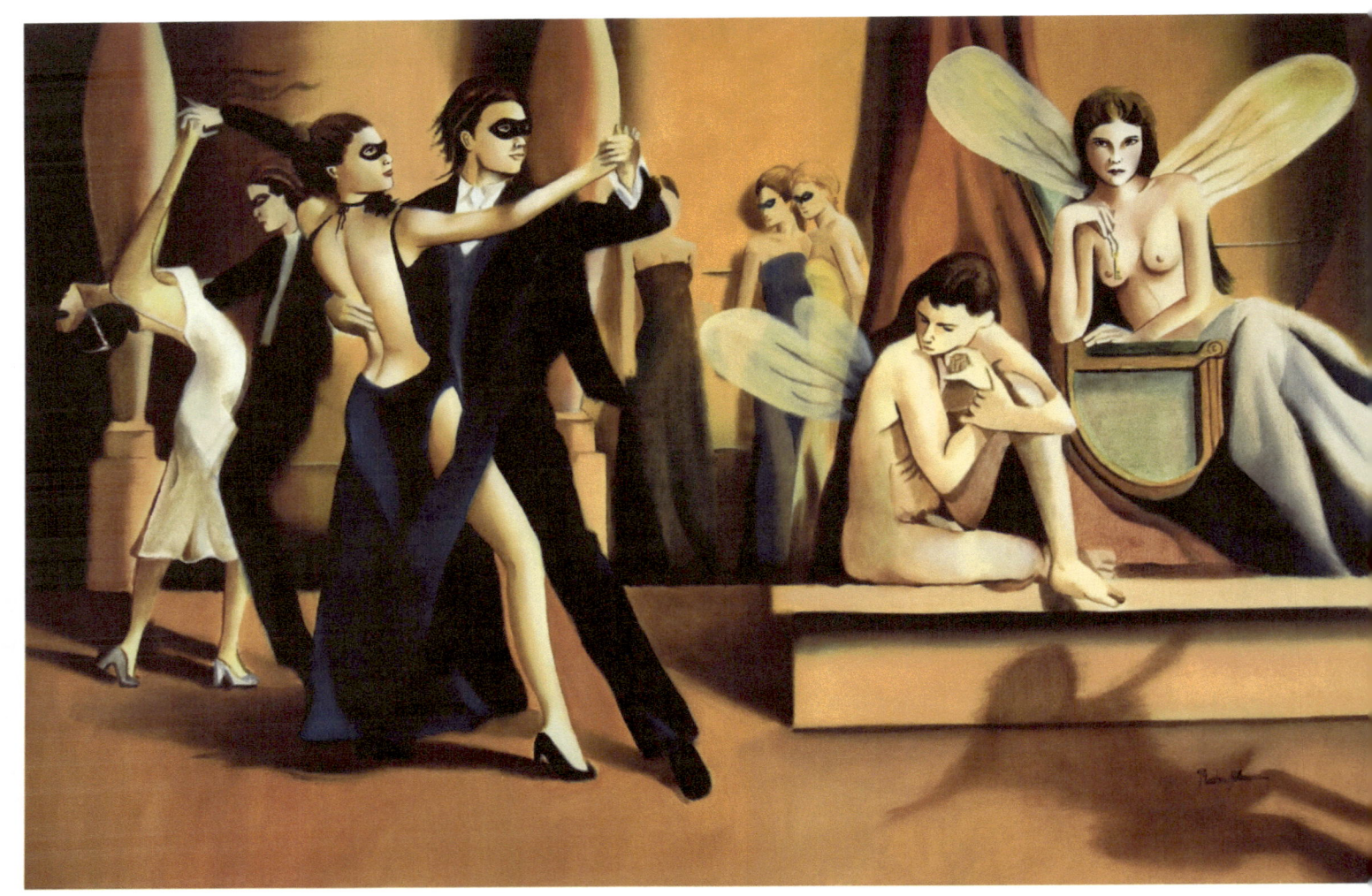

Masquerade
The Mask Collection
Oil on Canvas

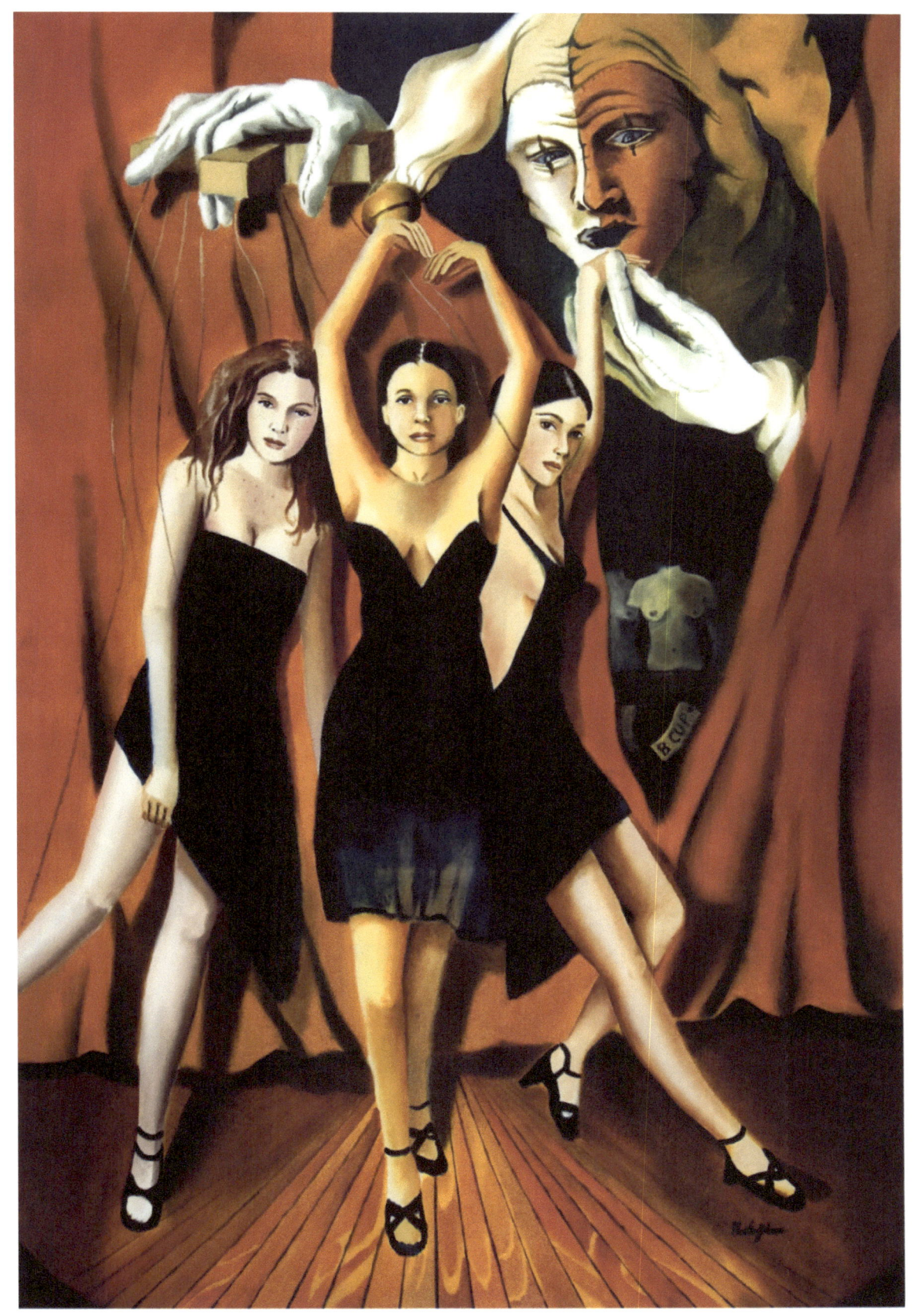

Little Black Dress

The Mask Collection

Oil on Canvas

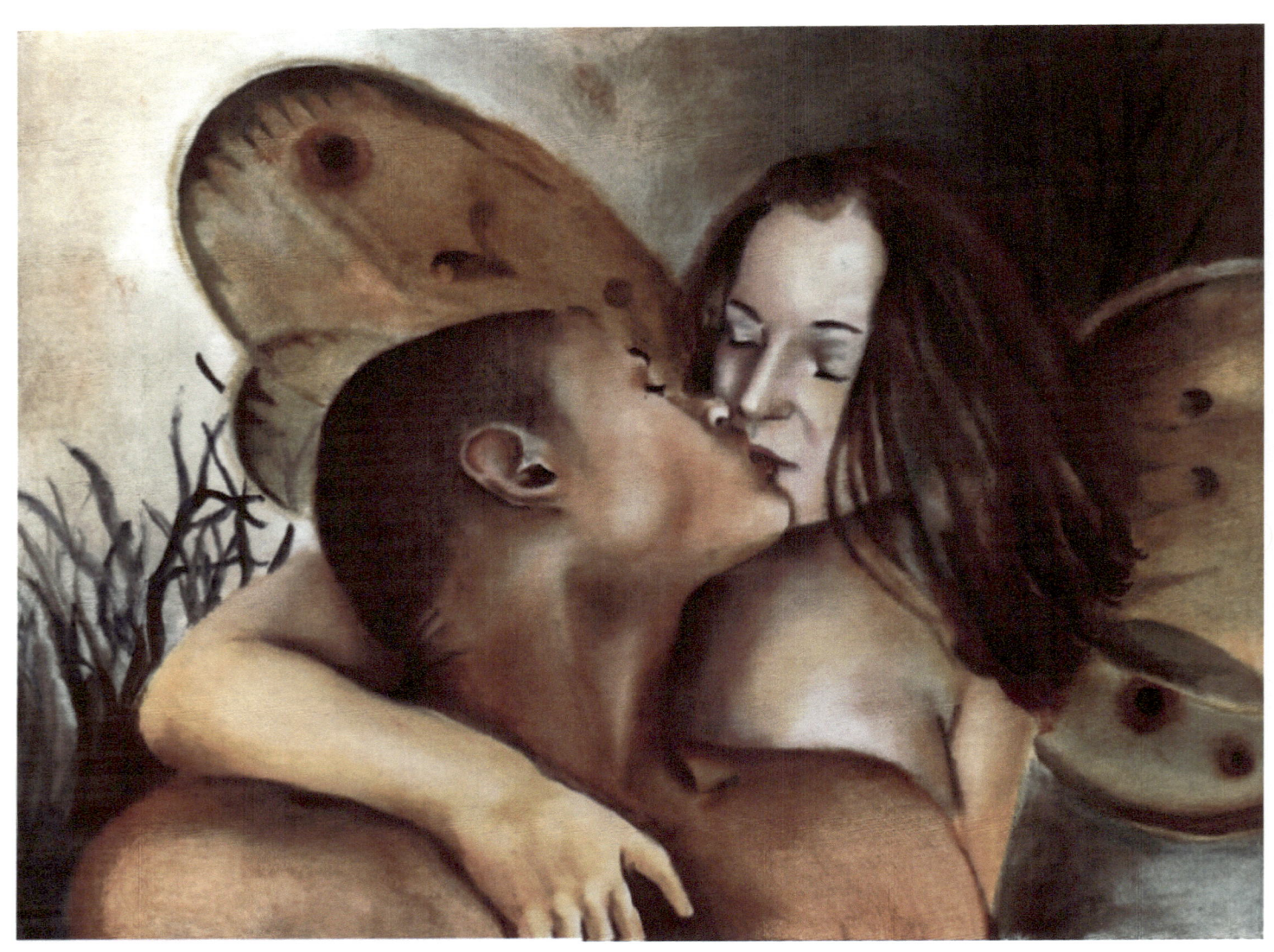

The Kiss

Oil on Board

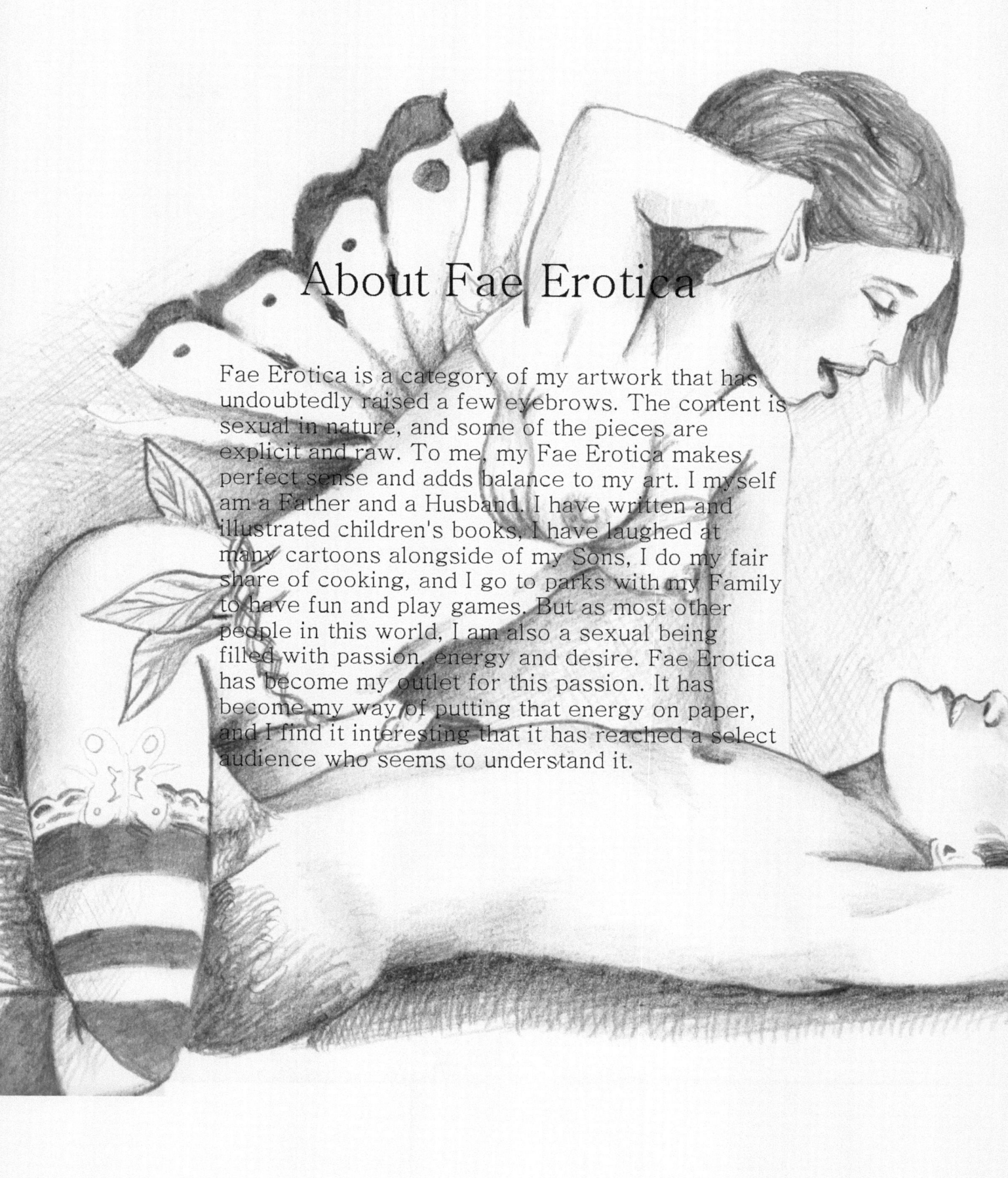

About Fae Erotica

Fae Erotica is a category of my artwork that has undoubtedly raised a few eyebrows. The content is sexual in nature, and some of the pieces are explicit and raw. To me, my Fae Erotica makes perfect sense and adds balance to my art. I myself am a Father and a Husband. I have written and illustrated children's books, I have laughed at many cartoons alongside of my Sons, I do my fair share of cooking, and I go to parks with my Family to have fun and play games. But as most other people in this world, I am also a sexual being filled with passion, energy and desire. Fae Erotica has become my outlet for this passion. It has become my way of putting that energy on paper, and I find it interesting that it has reached a select audience who seems to understand it.

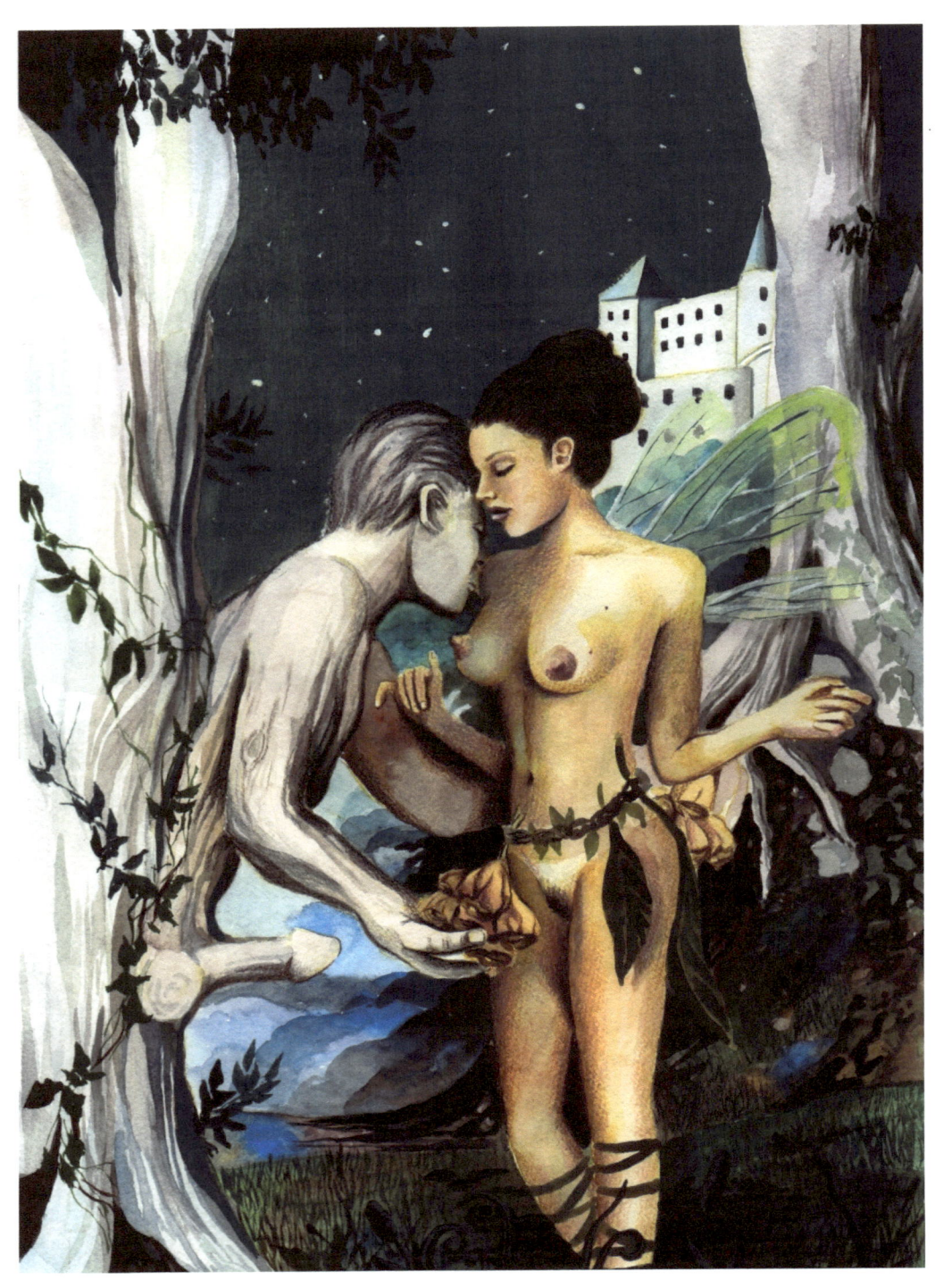

Adorn
Fae Erotica
Watercolor, Colored Pencil and Acrylic

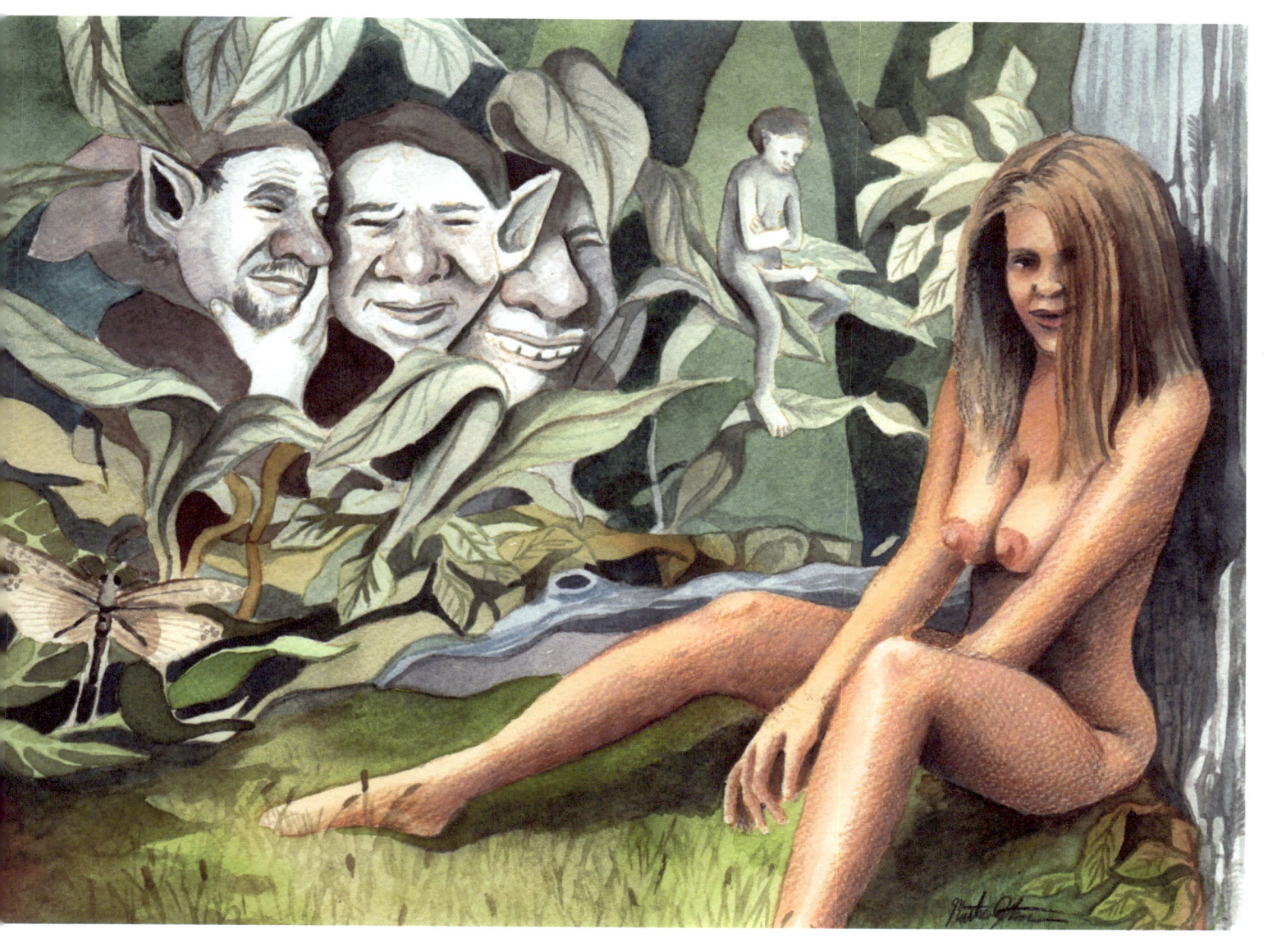

Simple Pleasures
Fae Erotica
Watercolor and Colored Pencil

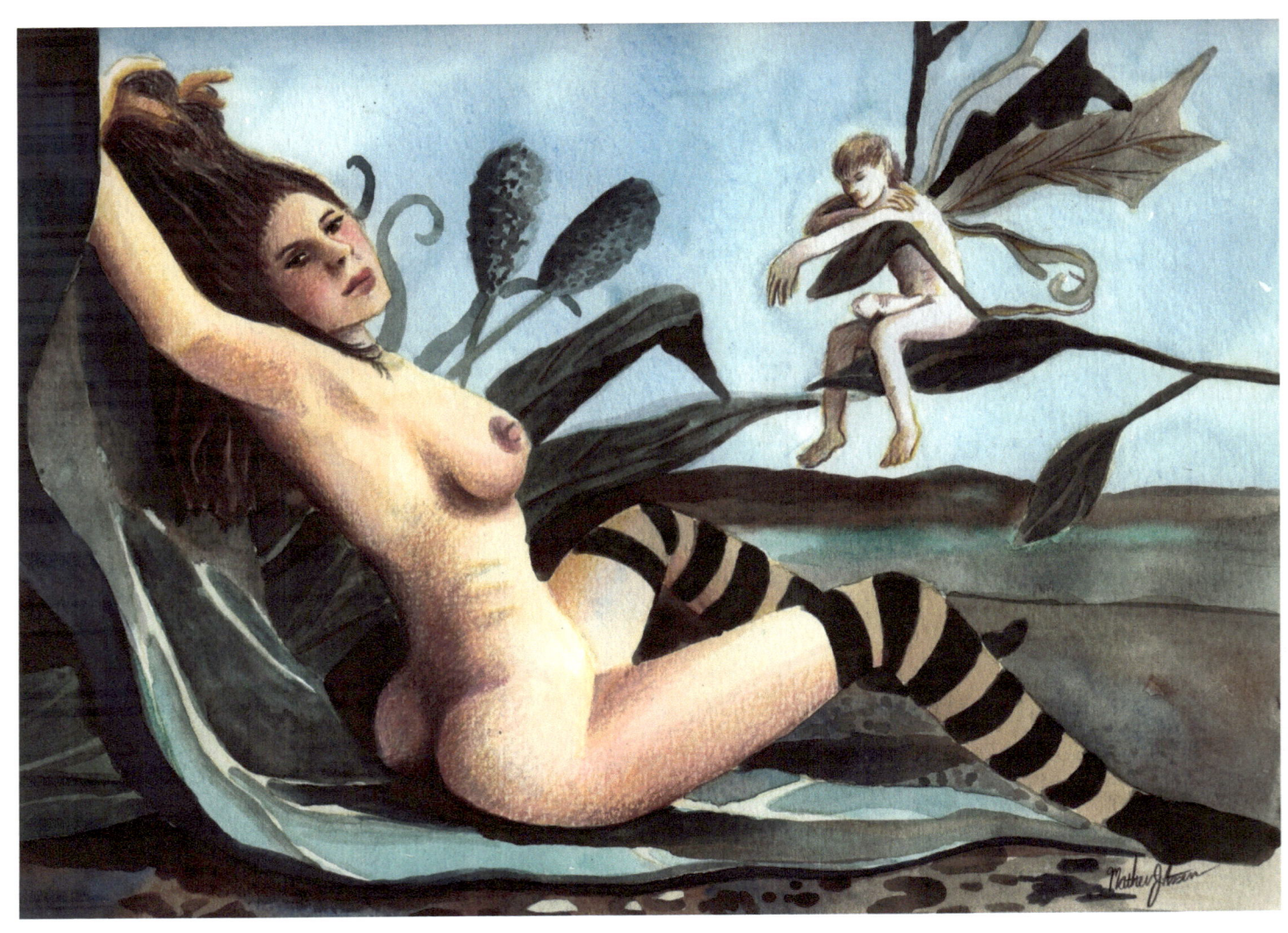

The Admirer
Fae Erotica
Watercolor and Colored Pencil

www.ingramcontent.com/pod-product-compliance
Lightning Source LLC
Chambersburg PA
CBHW041300180526
45172CB00003B/914